IMAGES
of America

EMERALD BAY AND DESOLATION WILDERNESS

IMAGES
of America

EMERALD BAY AND DESOLATION WILDERNESS

Peter Goin

ARCADIA
PUBLISHING

Copyright © 2018 by Peter Goin
ISBN 978-1-4671-2818-6

Published by Arcadia Publishing
Charleston, South Carolina

Printed in the United States of America

Library of Congress Control Number: 2017964046

For all general information, please contact Arcadia Publishing:
Telephone 843-853-2070
Fax 843-853-0044
E-mail sales@arcadiapublishing.com
For customer service and orders:
Toll-Free 1-888-313-2665

Visit us on the Internet at www.arcadiapublishing.com

*To those archivists, researchers, and people of Tahoe who
continually find Emerald Bay and Desolation Wilderness
among the most amazing landscapes in all of America . . .*

CONTENTS

ACKNOWLEDGMENTS

This visual history of Emerald Bay and Desolation Wilderness depends upon the support of many volunteers, archivists, and researchers at nonprofit historical societies and libraries, including but not limited to the California State Parks Archives; Lake Tahoe Historical Society; Nevada Historical Society; North Lake Tahoe Historical Society; and Special Collections, Mathewson-IGT Knowledge Center, University of Nevada.

Many people, including those unidentified photographers of Lake Tahoe, helped make this book possible. However, the following people deserve special mention because of their good humor, gracious understanding, and unselfish assistance: Rosemary Reyes, of Seattle, Washington, and Vaughn Lewis, of New York, who both participated in the Research Experience for Undergraduates program (REU), a 10-week scholarship program during the summer 2016. They joined our team in fieldwork and image research, and their efforts were funded through the National Science Foundation Award No. 1263352. Our research team included students Marie Dyer, Dani Rawson, Sienna Shane, and Mychelle Vincent. Shelby McAuliffe, research assistant for the author, was extremely helpful and dependable whenever called upon. Scott Hinton, coordinator of photographic research at the University of Nevada, Reno, provided his usual high level of support in preparing the images for publication.

FURTHER READINGS

Bliss, William, and Sessions Wheeler. *Tahoe Heritage: The Bliss Family of Glenbrook, Nevada.* Reno: University of Nevada Press, 1997.

Goin, Peter. *Lake Tahoe.* Charleston, SC: Arcadia Publishing, 2005.

———. *Lake Tahoe: A Maritime History.* Charleston, SC: Arcadia Publishing, 2012.

———. *South Lake Tahoe.* Charleston, SC: Arcadia Publishing, 2010.

———. *Stopping Time: A Rephotographic Survey of Lake Tahoe* and *Arid Waters.* Albuquerque, NM: University of New Mexico Press, 1992.

James, George Wharton. *Lake of the Sky.* Las Vegas: Nevada Publications, published by Stanley Paher, 1992.

Landauer, Lyndall Baker. *The Mountain Sea: A History of Lake Tahoe.* Stow, MA: Flying Cloud Press, 1996.

Lekisch, Barbara. *Tahoe Place Names: The Origin and History of Names in the Lake Tahoe Basin.* Lafayette, CA: Great West Books, 1998.

Scott, E.B. *The Saga of Lake Tahoe.* vol. 1. Antioch, CA: Sierra-Tahoe Publishing Co., 1957.

———. *The Saga of Lake Tahoe.* vol. 2. Antioch, CA: Sierra-Tahoe Publishing Co., 1973.

Smith, Helen Henry. *Vikingsholm: Tahoe's Hidden Castle.* Palo Alto, CA: H.H. Smith, 1973.

Strong, Douglas H. *Tahoe: An Environmental History.* Lincoln: University of Nebraska Press, 1984.

INTRODUCTION

Emerald Bay sparkles as a diamond within the jeweled landscape known as Lake Tahoe. Designated a National Natural Landmark in 1968, Emerald Bay was formed by a mass of rocks and sediment—moraines—carried down and deposited by receding glaciers. The contoured, teardrop-shaped inlet reveals an excellent example of glacial geology. Not only is Emerald Bay one of the most photographed landscapes in the Sierra, it features Eagle Falls, Fannette Island, and California's first underwater park, Emerald Bay State Underwater Park, with two sunken barges, among other smaller craft, from the early days of resource exploitation and the construction of Vikingsholm.

Emerald Bay's spectacular beauty attracted in the late 1860s one of the first summer homes in all of Lake Tahoe. Ben Holladay, stagecoach magnate, constructed a home where Eagle Falls' creek merges into Lake Tahoe. In 1880, Paul Kirby, a wealthy physician from Carson City, Nevada, and his wife, Lucy, purchased the 500-acre parcel. The Kirbys built a number of cabins, a small hotel, and a steamer landing and planted vegetable gardens and brought a cow over from Glenbrook with hopes of starting a dairy. Three years after Dr. Kirby's death in 1889, the William Henry Armstrong family acquired the property and used the cabins as their summer residence for over 32 years.

In 1928, Lora Josephine Knight bought the Armstrongs' land desiring to build a summer home that would complement the stellar natural surroundings. Adopting the mantle of grandeur and magnificence, Lora Knight envisioned Vikingsholm, a 38-room mansion that is one of the most dramatic examples of historic Scandinavian architecture in the United States. Lennart Palme, married to Lora Josephine Knight's niece, was the architect who created the simulacrum of Swedish stone churches, 11th-century castles, and Nordic carved doorways and decorations. Even the interior landscape featured Nordic fireplaces, intricately carved dragon beams, and antiques reflecting Norwegian themes. Vikingsholm was completed in 1929 and carefully integrated the multifaceted stone structure within old-growth trees, ultimately respecting the locale's natural beauty. The construction included a small stone teahouse perched atop Fannette Island, Lake Tahoe's only island. Lora Knight had the teahouse built for entertaining her friends with high tea and the framed view of the bay and Cave Rock, directly across the lake to the east.

Today, the teahouse is a visually prominent ruin, sans roof or other historic artifacts. From 1863 to 1873, Capt. Dick Barter, a retired British sea captain, was the caretaker of Ben Holladay's property, which included the isle. During that time, Captain Barter built on the island his own tomb and chapel. However, in 1873, the eccentric captain, nicknamed "the Hermit of Emerald Bay," was lost in a storm off Rubicon Point, never to be found. Throughout historical accounts, photographs, and maps, Fannette Island has had many names, including Baranoff, Coquette, Dead Man's, Emerald Isle, and, not surprisingly, Hermit's.

Wa She Shu, the Washoe people, were the original inhabitants of Da ow aga (Lake Tahoe). *Da ow* means "lake," and "Tahoe" is a mispronunciation of the Washo word. Advancing settlements and commercial exploitation of the Lake Tahoe Basin continued unabated without including the Washoe people or tribal engagement, regardless of the fact that Emerald Bay fits within the center of ancestral Washoe trade routes. Today, on its western shore, Lake Tahoe's only boating campground—Emerald Bay Boat-In Campground—occupies one of numerous historic Washoe summer lands' sites.

From 1881 to 1959, the site was the Emerald Bay Resort & Camp, and it operated as a popular vacation site replete with cabins, steamer pier, and more permanent buildings. Overall, the site had 71 structures, including 22 tents, and a water and septic system. In 1953, the State of California purchased from then owner and lumberman Harvey West all of Emerald Bay below the Highway

89 perimeter. The resort was permitted to continue operating under a lease agreement until 1959. After the permit expired, the site was demolished, and all the buildings were removed, and the next iteration of the western shore of Emerald Bay began. At the site in 1962, construction was approved for the Emerald Bay Boat-In Campground with pier and buoys.

Emerald Bay is a California State Park (established 1953) and includes Vikingsholm, the boat-in camp, Fannette Island, the underwater park, and Eagle Point Campground. The scenic Rubicon hiking trail wraps around Emerald Bay, with trailheads at Eagle Point campground, Vikingsholm, and D.L. Bliss State Park. The foot trail intersects the Emerald Bay Boat-In Camp. Emerald Bay is a dramatic gateway to the Desolation Wilderness.

Visitors to Emerald Bay enjoy a beckoning glimpse of the Desolation Wilderness framed between the steep slopes of Jakes and Maggies Peaks. By hiking uphill to Eagle Falls Trail and onward to Eagle Lake, the wilderness and its glacial history emerges, from bowl-shaped valleys and alpine lakes to staggering peaks abounding.

The Washoe explored and lived within and around what is now the Desolation Wilderness. There is evidence of temporary encampments, including obsidian arrow points as the Washoe moved through the area on their summer migration from the Carson Valley. Identified as "Devil's Valley" (for its wild appearance) on the Wheeler map of 1881, the landscape surrounding and including Desolation Wilderness was most often used for cattle grazing until 1931, when it became under federal designation the Desolation Valley Primitive Area. A mere five years after the Wilderness Act of 1964 became law, the Desolation Wilderness was established. This alpine highland valley of lakes, ridges, and peaks features the crest of the Sierra Nevada. The Tahoe Rim Trail and the Pacific Crest Trail pass within its boundary, and a quota system limits the number of visitors that may enter. The Desolation Wilderness is one of the most heavily used wilderness designated areas in the United States. There are 45 different permit zones with different quotas and 15 different trailheads operating within the Desolation Wilderness.

The Desolation Wilderness embraces the Crystal Range, and Pyramid Peak is the highest point (9,985 feet elevation). This popular Desolation Wilderness area is just less than 100 square miles and averages 12.5 miles in length and 8 miles wide, with elevations ranging from 6,500 feet to nearly 10,000 feet. There are 130 lakes scattered throughout the alpine topography. Desolation Valley contained a series of natural lakes—Medley Lakes—that in 1875 were dammed using granite boulders, creating the largest body of water—Lake Aloha—within the Desolation Wilderness. Water from this lake is released in the fall as part of the Upper American River Project, feeding power and water to the Sacramento Valley.

From 1934 to 1955, numerous additional dams were constructed in part to stabilize seasonal water flows and improve fish habitat. Countless waterfalls and streams intersect the hiking trails and granite landscapes. Red fir, lodgepole pine, Jeffrey pine, mountain hemlock, ponderosa pine, western juniper, and western white pine provide habitat for a rich variety of wildlife. Both mule deer and black bear, among numerous other mammals such as coyote, porcupine, and bobcat, are common. Consistent with the Wilderness Act of 1964, the Desolation Wilderness offers an opportunity for solitude, physical and mental challenge, scientific study, inspiration, and primitive recreation. The far-reaching goal is to leave only footprints, memories, and photographs.

One

EMERALD BAY LOCALE

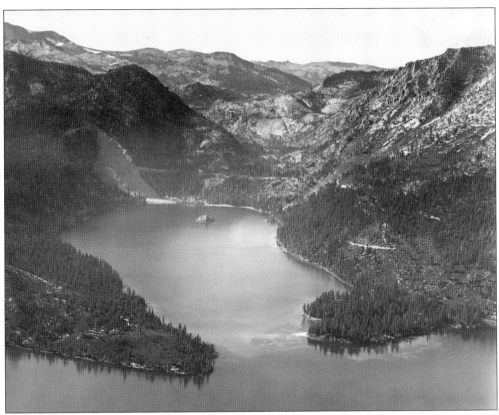

The name *Emerald Bay* first appeared on the Hoffmann topographical map of 1873. Today, Emerald Bay is one of the most photographed landscapes in the Sierra. The bay is slightly less than three miles in length and approximately two-thirds of a mile in width. This photograph was made c. 1950–1960 by Gene Christensen. (Courtesy of Special Collections, University of Nevada, Reno.)

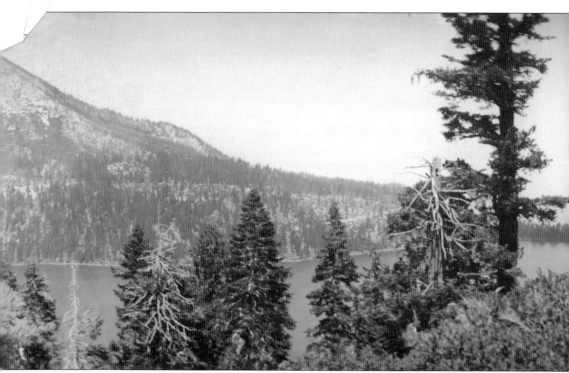

This panorama shows Emerald Bay and the narrow ridge-top road dividing Lake Tahoe to the west and Cascade Lake to the east. This image derives from the original Lincoln Highway Association (1910–1927), which consisted of automobile, tire, and cement industries promoting the first transcontinental highway in North America. The photography collection of the Lincoln Highway Association archive consists of approximately 3,000 images, including views of the construction of the first

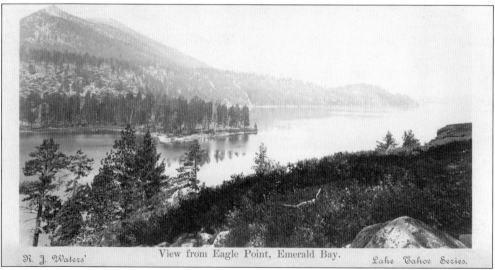

R. J. Waters' View from Eagle Point, Emerald Bay. Lake Tahoe Series.

"View from Eagle Point, Emerald Bay" is a c. 1880s R.J. Waters photograph from his *Lake Tahoe Series* of landscape scenes. Although today's view from a similar vantage point is oblique through new forest growth, this image captures the grand view at the time. Rubicon Peak is at the far left of the photograph. (Courtesy of the California Historical Society.)

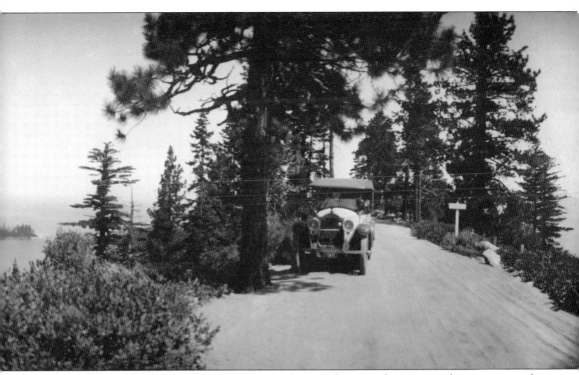

transcontinental highway and bridges, cars (such as in this image), cities, markers, towns, and posed photographs of association directors and field secretaries and "best general scenic views." (Courtesy of the Lincoln Highway Digital Image Collection, University of Michigan, Special Collections Library.)

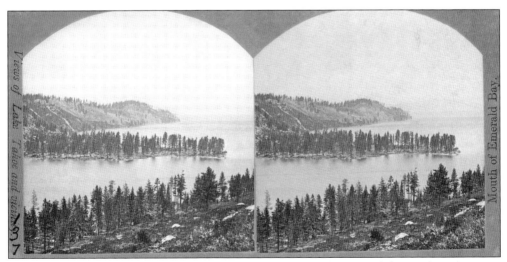

This stereocard is a view from Eagle Point, "Mouth of Emerald Bay," and derives from the series *Views of Lake Tahoe and Vicinity*. Photographer Romanzo E. Wood possibly made this c. 1881 photograph. Wood and his wife, Mary, traveled around California putting on optical lantern or stereopticon exhibitions and offered their services as landscape and portrait photographers. (Courtesy of the Nevada Historical Society.)

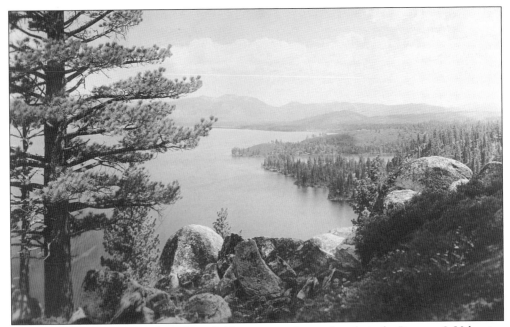

"Entrance to Emerald Bay, Lake Tahoe, Cal." is a postcard reproduced via the Putnam & Valentine collection of Lake Tahoe views. This vantage point is from the western highlands now part of the D.L. Bliss State Park. At the time of this photograph, it was possible to see over 100 feet into the depths of Lake Tahoe. (Courtesy of the Black Rock Institute.)

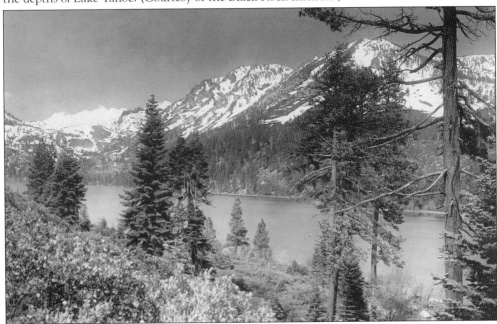

"Emerald Bay and Mountains, Lake Tahoe, Cal." is another in a large series of scenic views from the vast holdings of Putnam & Valentine. A snowy scene attests to the year-round beauty of Emerald Bay. The park is named after Duane Bliss, a pioneering lumberman, railroad owner, and banker; the Bliss family donated 744 acres to the state park system in 1929. (Courtesy of the Black Rock Institute.)

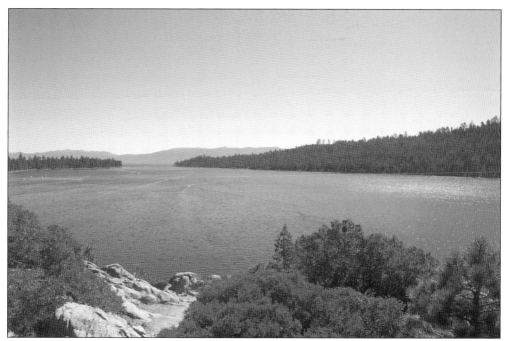

At the edge of the promontory lies the mouth of Emerald Bay, similar to Carleton Watkins's stereographic view below. The compelling nature of the view from atop Fannette Island creates the near perfect opportunity for rephotographing historical views made over the last 100 years. The author made this photograph in 2010 as part of a large rephotographic survey of Lake Tahoe. (Courtesy of the Peter Goin Collection.)

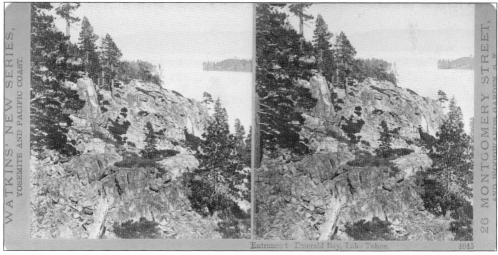

The "Entrance to Emerald Bay, Lake Tahoe" was a stereograph in Carleton Watkins's series *Yosemite and the Pacific Coast*. The view was made from the high rock face above the western shore of Emerald Bay, looking northeast. Carleton Watkins composed this view with preference to the foreground in order to exaggerate the effects of the three-dimensional illusion when viewed through the stereoscope viewer. (Courtesy of California State Library.)

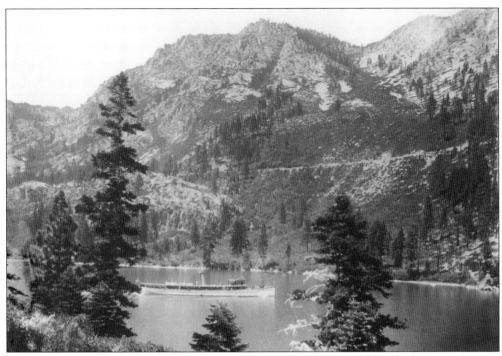

Appearing through the trees, the steamer *Tahoe* is on route around Emerald Bay. Launched in 1896 and starting regular tours in 1901, the *Tahoe* operated from Tahoe City's railroad pier and made a daily route around Lake Tahoe carrying passengers, freight, and the US mail. The road cut for California State Highway 89 is clearly visible halfway up the side of the mountain. (Courtesy of the North Lake Tahoe Historical Society.)

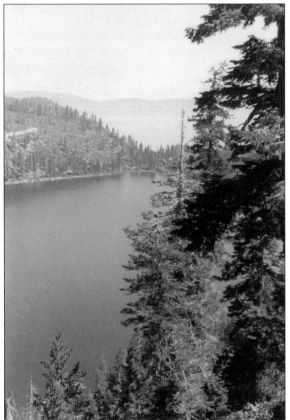

This view of the western edge of the landscape bordering the mouth of Emerald Bay reveals an ever-changing Lake Tahoe defined by the maturation of second- and third-growth forests. Today, this view is completely obstructed. (Courtesy of Harvard Art Museums/ Busch-Reisinger Museum, Gift of T. Lux Feininger, BRLF.1004.74.)

On Christmas Day 1955, a massive slide of disintegrated granite and boulders—200,00 cubic yards—demolished a section of Emerald Bay's Highway 89, exacerbated by a vertical fissure as much as 5 feet wide and 20 feet deep just above the roadway. After difficult and dangerous repair work, the highway opened again for traffic on November 3, 1956. This photograph was made in June 1956. (Courtesy of California State Parks, Image No. 090-28059.)

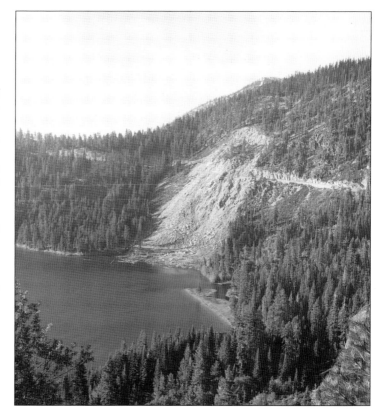

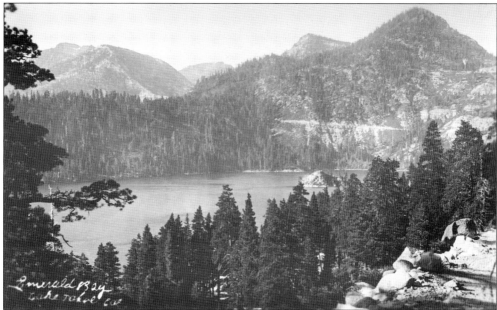

This photograph, made from the western cliffs of Emerald Bay beside the dirt roadway, shows Fannette Island just above the trees in the foreground and the road cut for Highway 89 in the distance. This view was made prior to the construction of the teahouse on the island and precedes the 1955 slide shown in the photograph at the top of this page. (Courtesy of the Nevada Historical Society.)

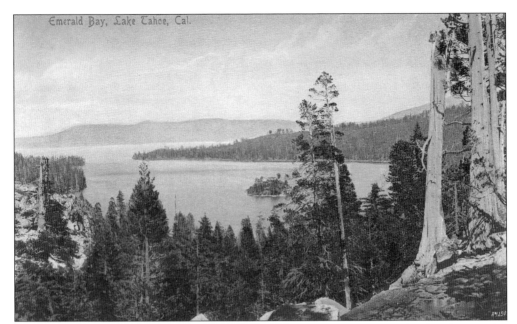

At the turn of the 19th to the 20th century, Emerald Bay views were immortalized in this popular hand-colored postcard format. In this particular card, mailed on November 7, 1907, the sender wrote about the "awfully pretty" scenery, sharing it with a friend in Diamond Springs, California. These vernacular postings contributed to the marketing of Lake Tahoe. (Courtesy of the Black Rock Institute.)

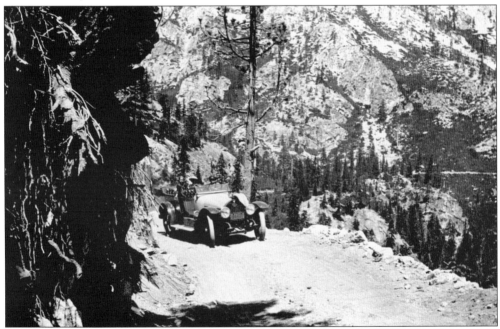

The construction of the rim-of-the-lake road through the steep and rocky terrain around Emerald Bay was heralded at the time by all the local news media as a milestone. Completed in 1913, what is now Highway 89 promised around-the-lake vehicle access and, as a consequence, sealed the inevitable demise of the steamer era. (Courtesy of the Lake Tahoe Historical Society.)

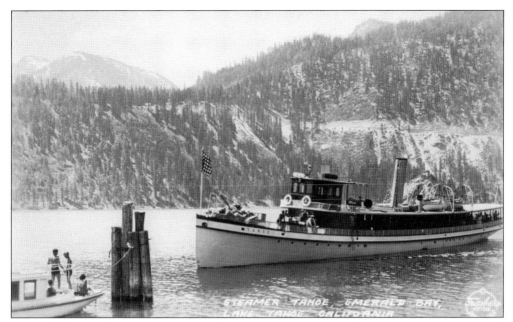

In the 1920s, the *Tahoe*, loaded with deliveries, luggage, and mail, slowly approaches Emerald Bay Resort & Camp. Burton Frasher Sr. was the photographer who made more than 3.5 million Frasher Fotos that were marketed nationwide. He traveled throughout the American Southwest, including Baja California and Sonora, Mexico. By the time of his death in 1955, Burton Frasher was considered the Southwest's most prolific photographer. (Courtesy of the Black Rock Institute.)

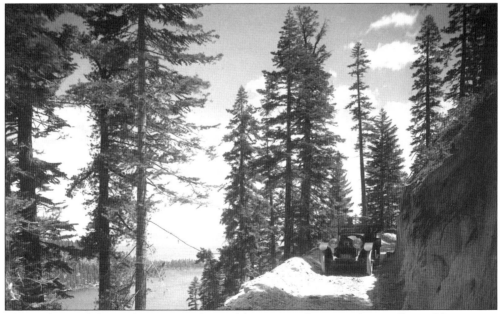

The road around the southern curve of Emerald Bay is treacherous and not well suited for two-way traffic. This automobile and unidentified passenger provide a sense of scale against the tree-lined backdrop of Emerald Bay's northwestern shore around 1915. This is similar to the Putnam & Valentine views of Lake Tahoe, photographed by John R. Putnam. (Courtesy of the North Lake Tahoe Historical Society.)

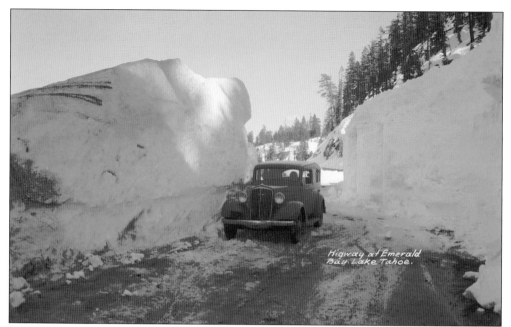

"Highway at Emerald Bay, Lake Tahoe" celebrates a winter wonderland at Lake Tahoe. Snow levels in the Sierra can reach dramatic heights, reminded principally by the Donner Party's horrific episode near Donner Lake and what is today Truckee, California. This 1934 or 1935 Chevrolet Series 4-Door automobile establishes a sense of scale, defining the height of the snowbanks along the roadway high above Emerald Bay. (Courtesy of the Black Rock Institute.)

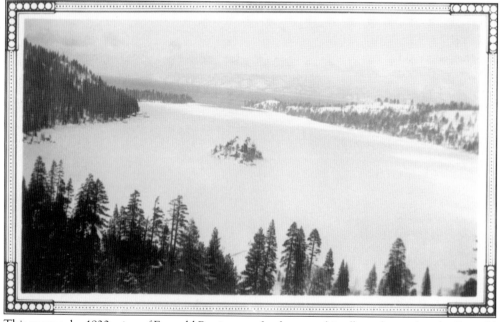

This vernacular 1930s view of Emerald Bay is part of a photographic album donated to the Emerald Bay State Park. Historically, Emerald Bay would freeze over during the coldest winter months, but that has not happened for decades. Ice harvesting operations focused on the bay's aquatic bounty, but no longer. (Courtesy of California State Parks, Image No. 090-26062.)

This image has at its center Fannette Island, Emerald Bay's jewel. As visitors to Lake Tahoe took to the roadways, and after the steamer and logging eras ended, the open, clear views of Lake Tahoe became fewer and farther away from each other. Consequently, the visual strategy of discovering, or framing, recognizable features within and around the bay required an ever-changing methodology of trying to find a suitable view. Pullouts are limited around the lake, especially along Emerald Bay's circumnavigated roadway where the steep mountainsides preclude parking. Enthusiasts or commercial entrepreneurs hoping to market Lake Tahoe's scenic wonder created most photographs of Emerald Bay's visual identity. However, this image is part of a collection of photographs that derive from a survey of the Lincoln Highway and scenic pleasures surrounding the highway's corridor. (Courtesy of the Lincoln Highway Digital Image Collection, University of Michigan, Special Collections Library.)

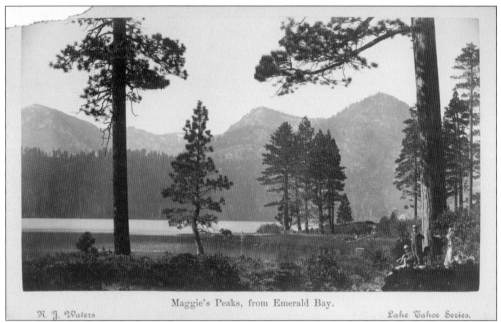

Maggie's Peaks, from Emerald Bay.

R. J. Waters Lake Tahoe Series.

"Maggie's Peaks from Emerald Bay" are sentinels to the Desolation Wilderness. The peaks have two prominences: the north peak is 8,499 feet and the south peak is 8,699 feet. According to local lore, Maggie was an attractive barmaid at the Tahoe Tavern. This c. 1895 photograph was made by R.J. Waters and is part of the Carl S. Dentzel Collection of the American West. (Courtesy of the Huntington Library, San Marino, California.)

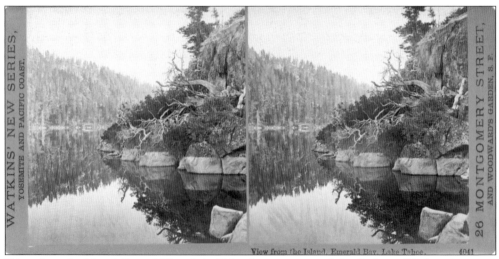

View from the Island, Emerald Bay, Lake Tahoe.

"View from the Island, Emerald Bay, Lake Tahoe" is a stereograph by Carleton Watkins featuring the dimension of stereoscopic viewing more than a topographic description of the landscape. The image is organized formally around positive and negative space and facilitates the viewer's pleasure. The island now named Fannette has had many names throughout its history, from Baranoff, Coquette, Dead Man's, and Ellen's to Hermit's. (Courtesy of the California State Library.)

Washoe women are posing in front of a *galis dangal*, known in lay terms as a winter house. These shelters were usually 12–15 feet in diameter—bark slab leaning against a structure of poles, fire pit in the center, and the door facing east. This *galis dangal* was set up within the Emerald Bay Resort & Camp that operated from 1881 to 1959. (Courtesy of the North Lake Tahoe Historical Society.)

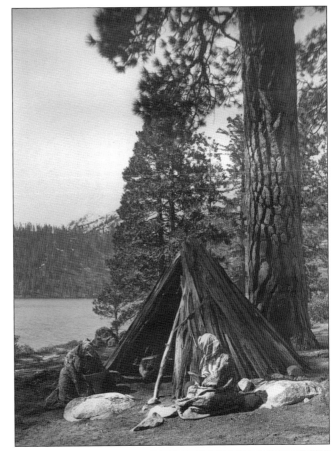

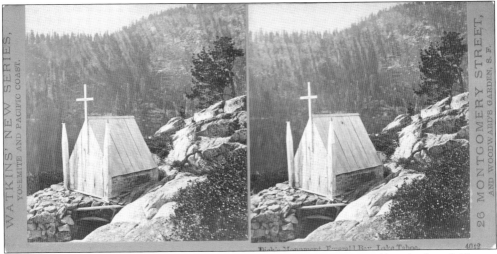

"Dick's Monument, Emerald Bay, Lake Tahoe" was Capt. Dick Barter's self-made chapel. He was a retired British sea captain and the caretaker of Ben Holladay's property, which included what is now Fannette Island. Captain Barter built his own tomb on the island but was unable to use it due to his untimely demise during a fierce storm off Rubicon Point. (Courtesy of the California State Library.)

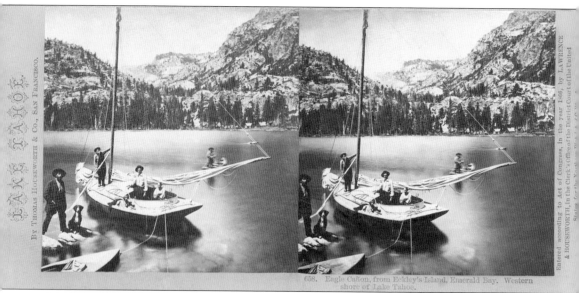

658. Eagle Cañon, from Eckley's Island, Emerald Bay. Western shore of Lake Tahoe.

"Eagle Cañon, from Eckley's Island, Emerald Bay" is the original stereograph marketed by Thomas Houseworth & Co. around 1865–1866. In many publications about Lake Tahoe's history, this stereograph was dissected such that only one image was presented within the narrative. However, the three-dimensional illusion is an aspect of how the landscape was viewed and subsequently framed. Dr. Paul Kirby, of Carson City, Nevada, owned the property. Dr. Kirby and his wife, Lucy, are at the helm of *Fleta*, their sailing boat. The photograph was made from present-day Fannette Island (titled rarely as Eckley's Island). Dr. Kirby had purchased 500 acres of land fronting the northwest side of Emerald Bay, and by 1884, the Kirbys' Emerald Bay holdings included a small hotel, several basic cottages, tents, and a steamer landing. Lucy managed the vegetable garden, and the Kirbys rafted a lone cow across the lake from Glenbrook to provide milk for guests. In the background is the site of present-day Vikingsholm. (Courtesy of Special Collections, University of Nevada, Reno.)

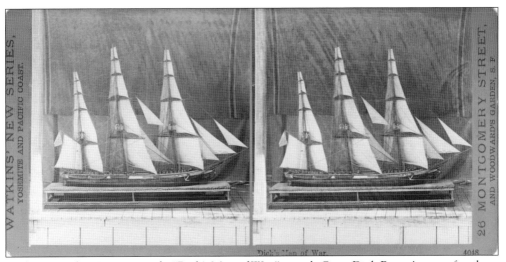

Carleton Watkins's stereograph, "Dick's Man of War," reveals Capt. Dick Barter's seven-foot-long fully rigged steam frigate, replete with carved, highly detailed figures, guns, and other tools of the maritime trade. In the vessel's hold, a clock's running gear operates the propeller. He crafted the replica during an 11-week confinement after suffering a terrible bout of frostbite on his feet and one hand. (Courtesy of the California State Library.)

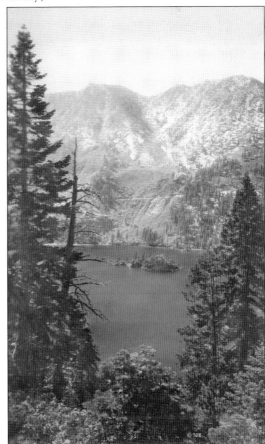

"Emerald Bay, Dead Man's Isle" is a postcard, and its text amplifies the oral histories surrounding Capt. Dick Barter and his untimely and mysterious demise. The title alludes to the mystery of his disappearance, especially since the official name of the island is Fannette. The landscape is embellished with hand-colored greens and blues, emphasizing the island's colloquial identity. (Courtesy of Special Collections, University of Nevada, Reno.)

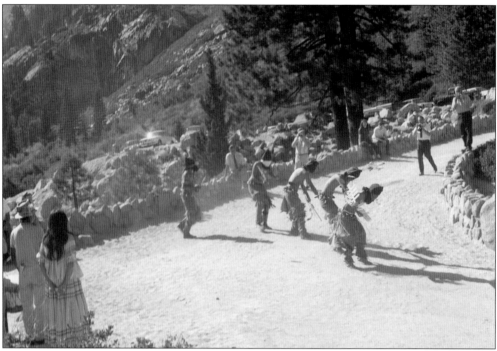

Emerald Bay was designated a California State Park in 1953 and, due to its spectacular glacial geology, a National Natural Landmark in 1968. Upon Congressional authorization, Interior Secretary Stewart L. Udall conferred the Natural Landmark status resulting in a dedication ceremony on September 27, 1969. The master of ceremonies was Jerry Martin, chairman of the El Dorado County Board of Supervisors. William Penn Mott Jr., director of the State Department of Parks and Recreation, spoke on the need to preserve the Lake Tahoe Basin to the more than 100 people gathered. The plaque can be seen in the parking area on Highway 89, above Vikingsholm. Members of the Stewart Indian School performed "The Dance of the Mountain Spirits" as part of the program. Both Washoe and California Hoopa Indians were present. (Above, courtesy of California State Parks, Image No. 090-28078; below, courtesy of California State Parks, Image No. 090-28083.)

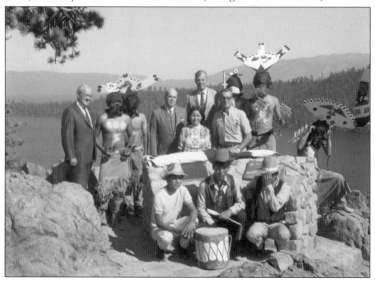

Two

FANNETTE ISLAND

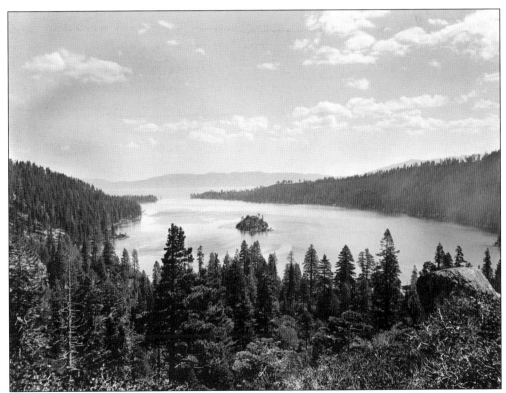

Fannette Island, Emerald Bay, is the only island on Lake Tahoe. Throughout the lake's cartographic and visual history, the island has been named Baranoff, Coquette, Dead Man's, Eckley's, Emerald Isle, and Hermit's. It is only accessible by watercraft, as swimming to the island is prohibited. The teahouse at the summit was constructed between 1928 and 1929. This 1914 photograph was made by Frederick W. Martin. (Courtesy of the California State Library.)

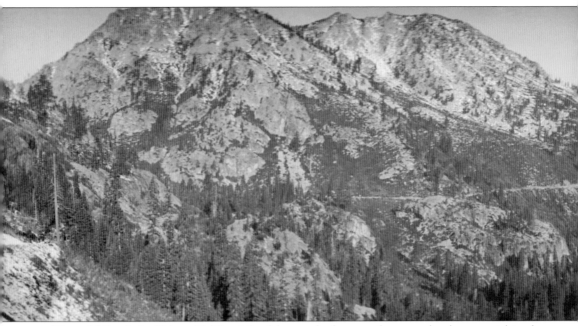

"Emerald Bay, Lake Tahoe, California" celebrates the beauty of western landscapes within the vicinity of the Lincoln Highway, which is today's Interstate Highway 80. The Lincoln Highway stretched originally for 3,389 miles from coast to coast and ran parallel to Truckee, California, and Donner Lake. The history of the Interstate Highway System promoted the development and marketing of scenic byways, which includes this panorama of Emerald Bay. Fannette Island, center

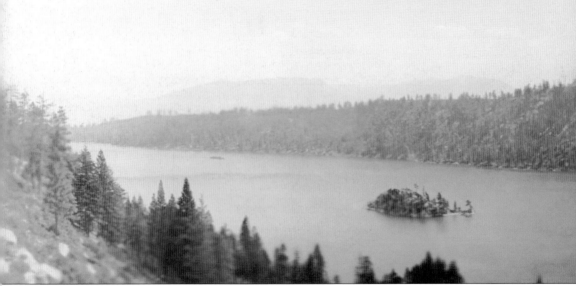

An unidentified photographer made this panorama in 1920. The image details a view from the road above Emerald Bay. The road was completed in 1913, and circumnavigates the bay, connecting Lake Tahoe's east and west shores. It is visible along the slope of Maggies Peaks, at right. This ancillary image to the Lincoln Highway place the development of Lake Tahoe's tourism into a larger context. As the first automobile road across the United States, the Lincoln Highway was

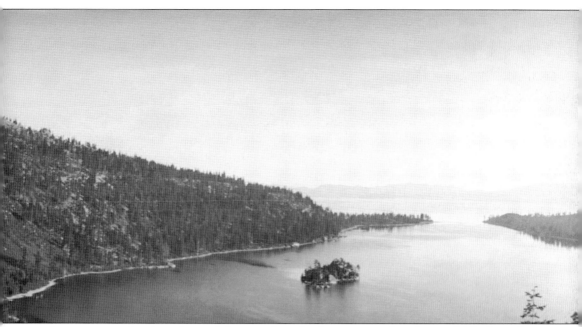

right, remains to this day a focus of photographers, both amateur and professional. The Lincoln Highway was replaced in 1926 with the ubiquitous designations of the US Numbered Highway System. This photograph was made on October 8, 1920. (Courtesy of the Lincoln Highway Digital Image Collection, University of Michigan, Special Collections Library.)

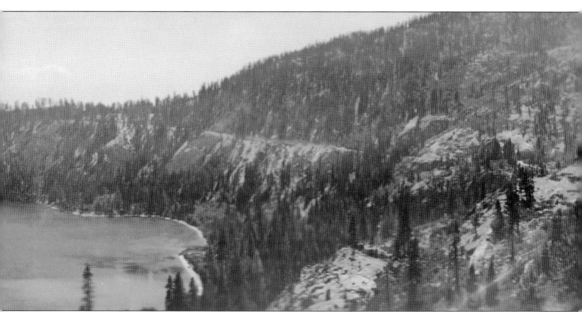

defined as America's Main Street. The highway was a national memorial to Abraham Lincoln. After the Lincoln Highway's completion, the public's enthusiasm for accessible roadways led to the federal government's involvement. (Courtesy of the University of Michigan, Special Collections Library.)

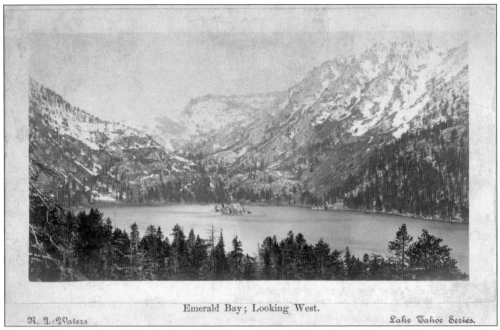

Emerald Bay; Looking West.

R. J. Waters Lake Tahoe Series.

"Emerald Bay, Looking West" is from R.J. Waters's *Lake Tahoe Series*. This c. 1886 view precedes the building of Vikingsholm and Fannette Island's teahouse. R.J. Waters traveled throughout the Lake Tahoe area, and his collection of photographs encapsulates the magic and wonder of Emerald Bay's spectacular beauty. The view was made along the Eagle Point promontory. (Courtesy of the California Historical Society.)

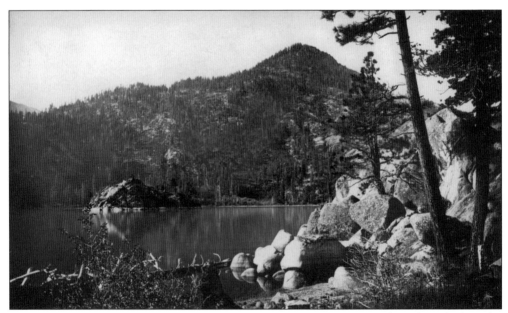

"A Scene in Emerald Bay" was made at the campsite facing Parson Rock, right, which is the southern edge of today's Emerald Bay Boat-in Camp. During Sunday sermons, preachers would use these rocks as their pulpits. R.J. Waters's c. 1919 vantage point is present-day campsite No. 1, one of the most popular sites at the campground. (Courtesy of the Nevada Historical Society.)

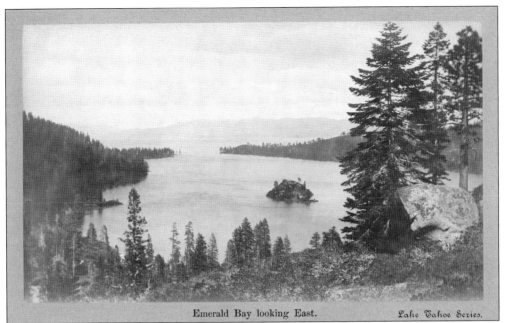

Emerald Bay looking East. Lake Tahoe Series.

"Emerald Bay looking East" is one of the quintessential views of Emerald Bay. This c. 1919 view was made slightly west and downslope of Inspiration Point along what is now Highway 89. R.J. Waters included the boulder, right, as a compositional element contrasting Fannette Island. There are numerous historical photographs of unidentified viewers seated on the same boulder. (Courtesy of the California Historical Society.)

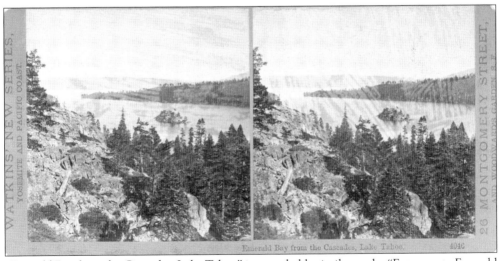

Emerald Bay from the Cascades, Lake Tahoe. 4040

"Emerald Bay from the Cascades, Lake Tahoe" is remarkably similar to the "Entrance to Emerald Bay, Lake Tahoe" (refer to the bottom of page 13). Carleton Watkins created a variety of views in the Lake Tahoe area, documenting his appreciation for the western landscape. The "Cascades" refers to Cascade Falls and Cascade Lake, located southwest of Emerald Bay. (Courtesy of the California State Library.)

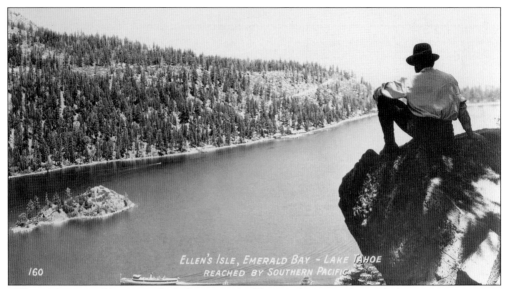

"Ellen's Isle, Emerald Bay—Lake Tahoe, Reached by Southern Pacific" includes a viewer enjoying the scene from an overhanging boulder. Note the SS *Tahoe* circumnavigating Emerald Bay and Fannette Island. Ellen's Isle is a rare nomenclature and rarely duplicated in other historical accounts. The individual posing is California Highway superintendent Billings; the photograph was marketing tourism for the railroad. (Courtesy of the California Historical Society.)

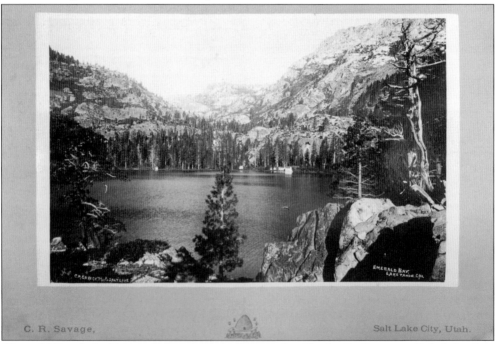

"Emerald Bay, Lake Tahoe, Cal." is a carte de visite by Charles R. Savage, a Salt Lake City photographer who traveled and photographed "best general views" extensively throughout the American West. This view is from the island, looking toward Eagle Falls and one of the central approaches to the Desolation Wilderness. (Courtesy of L. Tom Perry Special Collections, Harold B. Lee Library, Brigham Young University.)

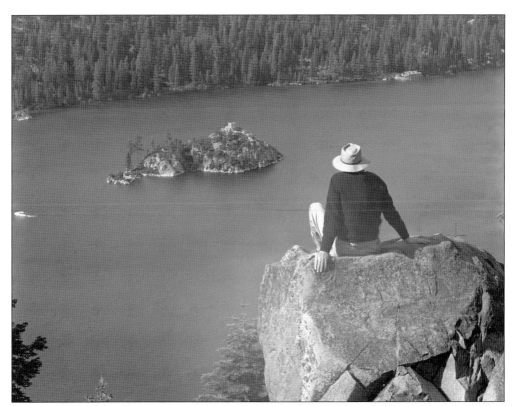

Photographer August "Gus" Bundy made this view around 1945–1950, paying homage to the numerous historical views of an unidentified visitor admiring Emerald Bay and Fannette Island from this boulder's perch. Gus Bundy settled in Nevada in 1941 and was a dedicated photographer whose collection is now held in the public trust by the University of Nevada, Reno. (Courtesy of Special Collections, University of Nevada, Reno.)

In the early 1870s, Carleton Watkins's made a stereograph of this exact view titled "The Cottage from the Island, Emerald Bay, Lake Tahoe." After a financial crisis, Watkins lost his earlier negatives to a creditor. Conceptually, the view is not of the island but from the island, creating a dynamic reference to the island's central importance. The author made this photograph in 2011. (Courtesy of the Peter Goin Collection.)

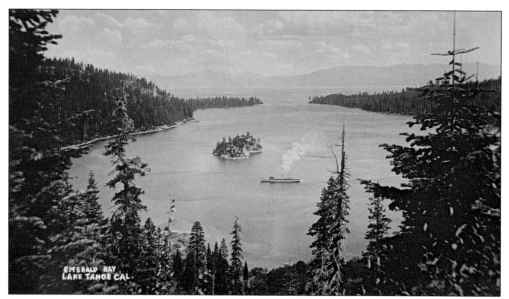

Fannette Island is the jewel within Emerald Bay, attracting steamship visitors from Tahoe City, Glenbrook, and South Lake Tahoe. During the steamer era, which unofficially began in 1864 with the relatively small SS *Governor Blaisdel*, passengers toured Emerald Bay, enjoying the scenic views. Coming around the southwestern edge of the island, the *Tahoe* is shown under full power. This photograph was made by Fritz A. Lentz. (Courtesy of the Black Rock Institute.)

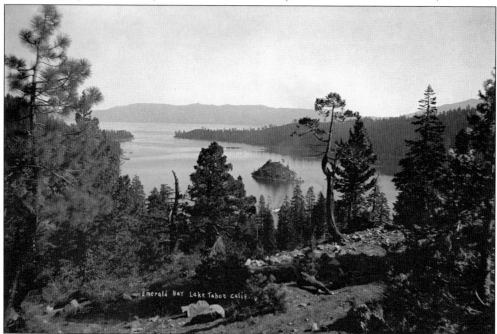

"Emerald Bay, Lake Tahoe, Calif." is one of a legion of images made from the southwestern cusp of Emerald Bay. These views of Fannette Island, the outer bay, and a steamer encircling the island have become icons in Lake Tahoe's visual lore. Amateur and professional photographers alike feel compelled to duplicate these views, paying homage to and endorsing the lake's essential beauty. (Courtesy of the Black Rock Institute.)

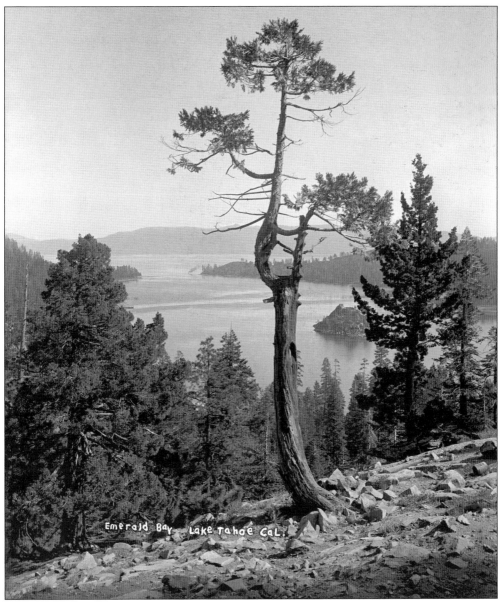

Emerald Bay Lake Tahoe Cal.

"Emerald Bay, Lake Tahoe, Calif." and the previous image with the same title were made by the same unidentified photographer. Although there is little evidence beyond these photographs, the images indicate a potential sequence of walking above and around the southern edges of the upper Bay, photographing the scenic splendor. The three images on these two pages, as well as numerous additional photographs of Emerald Bay and Fannette Island, have become iconic in endorsing how central this visual signage is in defining Lake Tahoe. Rarely is the expanse of the lake's geography and the distant rim an aesthetic focus. Instead, it is the confines of the curvature of the bay, the island's emphasis in the composition of the teardrop-shaped inlet, the narrative of the steamer's passage, and the mountain encumbrances that encapsulate Lake Tahoe as a place of alpine beauty. These images derive from glass-plate negatives, which were created after Fannette Island's teahouse was built. Note that the tree central in this image is also evident in the previous image, albeit less prominently. (Courtesy of the Black Rock Institute.)

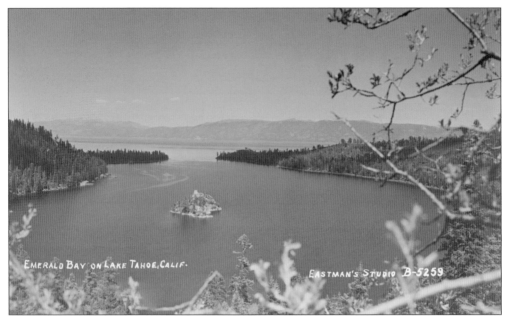

Both "Emerald Bay on Lake Tahoe, Calif." images were made by either Jervie Henry Eastman or his partner Mirl Simmons, of the Eastman & Company commercial photography and postcard business. In 1898, Eastman launched his career as a view photographer in the Mount Shasta area, but he lost all his photographic plates and postcards in a 1912 fire. Subsequently, in 1921, Eastman moved to Susanville, California, where he hired and then later partnered with Mirl Simmons, who was from Hillsborough, West Virginia. These images confirm quintessential views of Emerald Bay as mementos of a vacation or simply a tour around the lake. After the steamer era ended, visitors to the lake were most often relegated to making visual memories from predetermined roadside pullouts, similar to these views. (Both, courtesy of Special Collections, UC Davis Library [Eastman's Originals Collection B-5259 (above) and B-5261 (below)].)

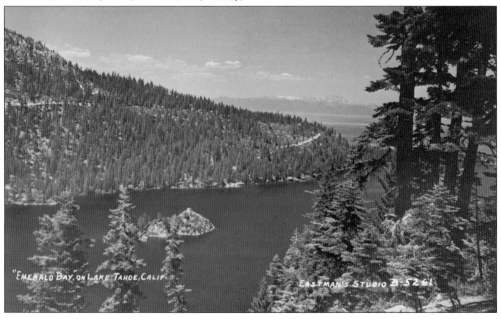

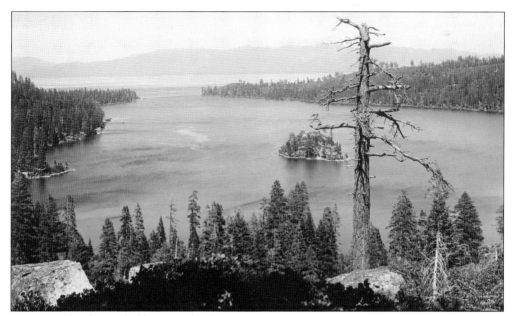

Fannette Island is probably an evolved mispronunciation of Coquette. The story alleges that a party of Sacramento ladies and gentlemen visited the island and left a description in a champagne bottle nestled in a crevice on the island in 1866. One of the ladies apparently named the island "Coquette" as it was the center of a brilliant circle of admirers, such as those on the *Tahoe* in the photograph below, who were only rebuked by her stony heart. This story was reported in the *Sacramento Daily Union* on August 4, 1866, and confirmed in Barbara Lekisch's *Tahoe Place Names*. (Above, courtesy of the Lake Tahoe Historical Society; below, courtesy of the North Lake Tahoe Historical Society.)

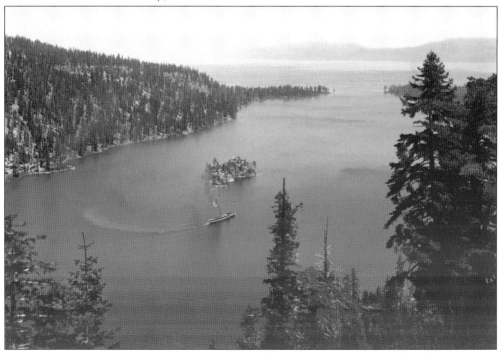

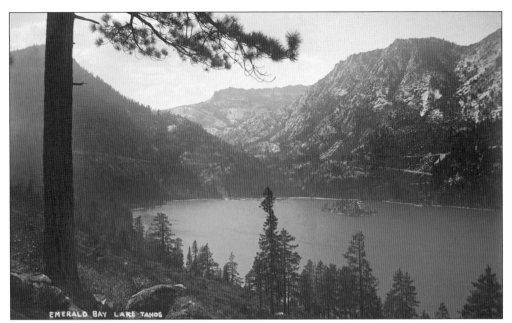

This view of Emerald Bay and Fannette Island encompasses Eldorado National Forest and the distant boundary of the Desolation Wilderness. Jakes Peak, to the right of the photograph, is the southernmost peak on Tahoe's western shore ridgeline. Unknown to most visitors, a few experienced backcountry skiers enjoy the variety of terrain, long vertical drops, and dramatic scenery of the bay and lake. (Courtesy of the Black Rock Institute.)

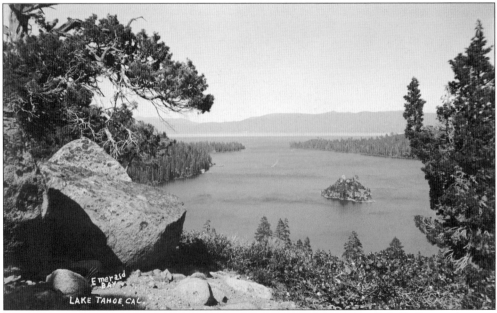

Lake Tahoe is unique among alpine lakes not just in the United States but globally. Researchers are focusing on studying how natural variability, landscape change, and human activity have affected the lake's clarity and natural ecosystems. The oft-repeated scenic celebrations—photographs such as these on both pages—reinforce the importance of Lake Tahoe as an analog for environmental health. (Courtesy of the Black Rock Institute.)

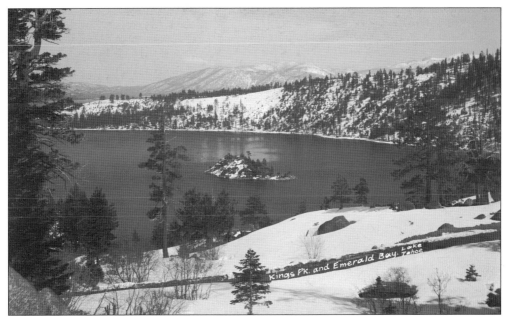

The "Kings Pk. And Emerald Bay, Lake Tahoe" view was made from above the dirt road circumnavigating Emerald Bay. Kings Peak is not marked on any Lake Tahoe Basin contemporary maps. Instead, the distant view encompasses East Peak, Monument Peak (center, distant), what is today Heavenly Mountain Resort, and Kingsbury Grade. Jobs, Sister, and Freel Peaks are on the right side of the photograph (Courtesy of the Black Rock Institute.)

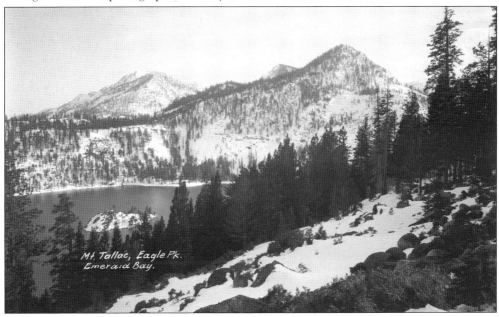

"Mt. Tallac, Eagle Pk. Emerald Bay" correctly identifies Mount Tallac (left), but what is identified as Eagle Peak is Maggies Peaks. While both Maggies Peaks are relatively small compared to other Lake Tahoe mountains, the view from either summit is spectacular, particularly of the Desolation Wilderness. They are prominently featured in the background during the credits of the *Bonanza* television show. (Courtesy of the Black Rock Institute.)

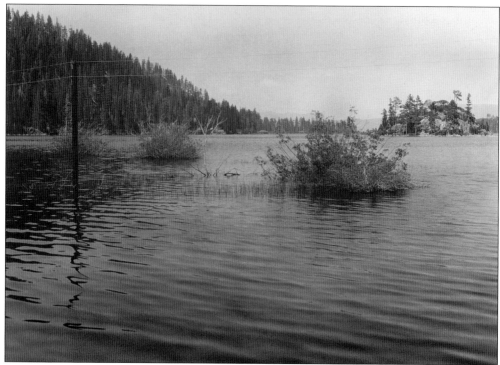

"Looking into Emerald Bay at the South side of the island" derives from the 1916 Lake Tahoe photographic shoreline survey. Further description notes that the camera was "pointing out into bay showing south side of Emerald Bay Island in distance and telephone line crossing end of bay. Water elevation in lake 6229.72 ft. July 19th, 1916." This photograph was made by Herford Tynes Cowling. (Courtesy of the North Lake Tahoe Historical Society.)

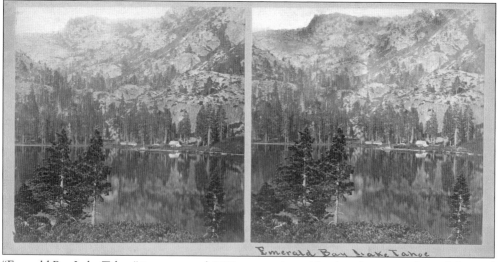

"Emerald Bay Lake Tahoe" is an unusual 1880s stereoview with a handwritten title, and the card is absent of any commercial printing identification. The view was made from the southwestern edge of Fannette Island, looking toward Paul and Lucy Kirby's holdings. In 1895, all but 120 acres of the original Kirby family estate were sold to the William Armstrong family. (Courtesy of the California State Library.)

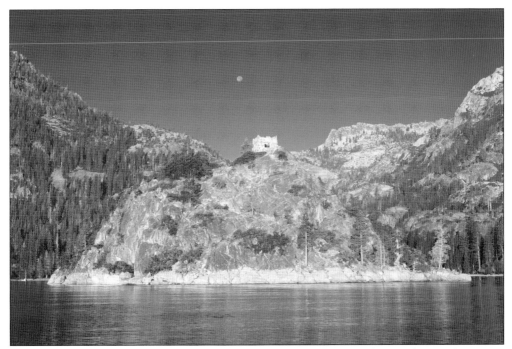

"Moon, Fannette Island, Emerald Bay, Lake Tahoe" is the author's aestheticized view of Fannette Island's castle. Directly referencing Ansel Adams's seminal image *Moonrise, Hernandez, New Mexico, 1941*, the composition emphasizes a formalized view of one of the most photographed locations in the Sierra Nevada. The castle is only a vernacular reference; the structure is a ruin and was originally Lora Knight's teahouse. (Courtesy of the Peter Goin Collection.)

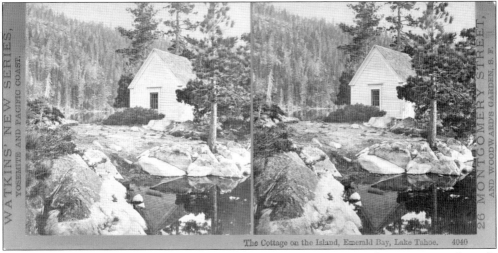

"The Cottage on the Island, Emerald Bay, Lake Tahoe" is Carleton Watkins's stereograph made from the water's edge of Fannette Island. Capt. Dick Barter, caretaker for Ben Holladay Jr.'s villa, often rowed his small craft *Nancy* to the Tahoe House saloon in Tahoe City. Having enjoyed his usual libations, he suffered from a fierce squall but survived, losing toes to frostbite in the process. (Courtesy of the California State Library.)

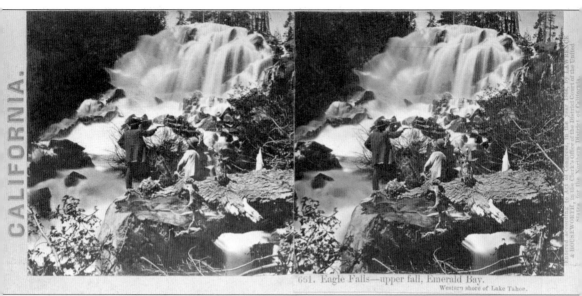

661. Eagle Falls—upper fall, Emerald Bay.
Western shore of Lake Tahoe.

"Eagle Falls—upper fall, Emerald Bay, Western Shore of Lake Tahoe" is from the 1867 acquisition by the Library of Congress of more than 900 albumen photographs by Lawrence & Houseworth, San Francisco. Eagle Falls is one of the most accessible and popular short-hike destinations at Lake Tahoe. The small parking lot located alongside Highway 89 is at the trailhead that leads approximately a quarter mile to the steel footbridge presiding over the falls. Renowned for its beautiful cascading water and lush green alpine scenery, Eagle Falls is the only waterfall that empties directly into Lake Tahoe. Given the convenient access and relatively few equivalent hikes nearby, this area is crowded during the summer months with recreationists, families with all ages of children, and dedicated backpackers. The hike up the steep granite path past the footbridge and the crest of the falls leads directly into the Desolation Wilderness. In this view, a man is posing with a pistol. This c. 1864–1865 photograph was most likely made by Charles Leander Weed. (Courtesy of the California State Library.)

Three

VIKINGSHOLM

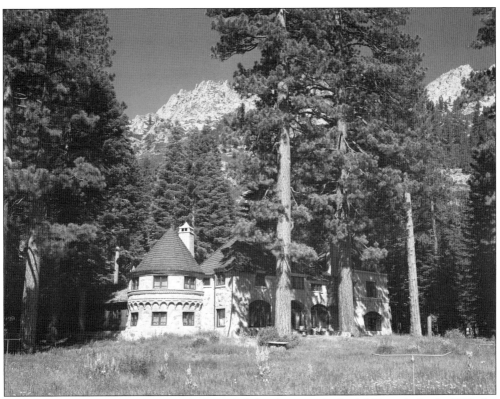

Lora Josephine Moore Knight was a dedicated philanthropist who built Vikingsholm. In 1928, she bought the Emerald Bay property, including Fannette Island, from William Henry Armstrong. She paid $250,000, which is approximately $3,560,000 in 2018. In 1892, the Armstrong family purchased the property from Ben Holladay Jr., son of the stagecoach magnate Ben Holladay. This August 16, 1953, photograph was made by John Shrawder. (Courtesy of California State Parks, Image No. 090-27544.)

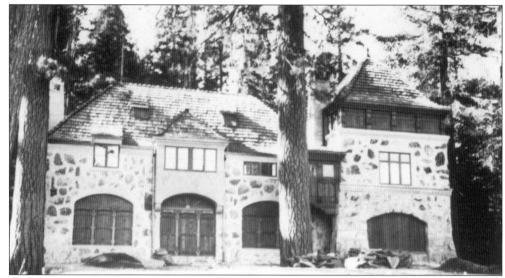

Lora Knight, heir to the fortune of National Biscuit, Continental Can, Diamond Match, Union Pacific, and the Rock Island Railroad, imagined the Nordic-themed Vikingsholm, a 38-room mansion that is one of the most dramatic examples of historic Scandinavian architecture in the United States. This photograph was made around 1929, shortly after her summer home's completion. Today, Vikingsholm is Emerald Bay State Park's jewel. (Courtesy of California State Parks, Image No. 090-25993.)

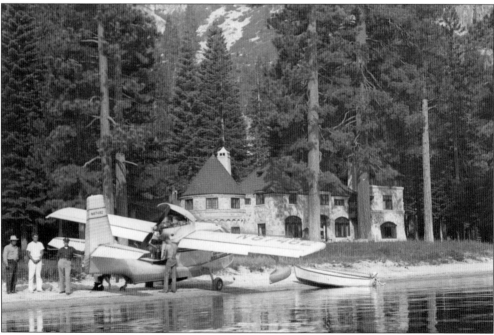

Lora Knight spent 15 summers at Vikingsholm, regularly entertaining guests. After she died at the age of 82 in 1945, the estate was sold to Nevada rancher Lawrence Holland and shortly thereafter to Harvey West, a successful lumberman from Placerville, California. This seaplane was visiting the estate in the early 1950s; Wes Stetson was the pilot, standing at left. This photograph was made by Vern Cartwright. (Courtesy of California State Parks, Image No. 090-28071.)

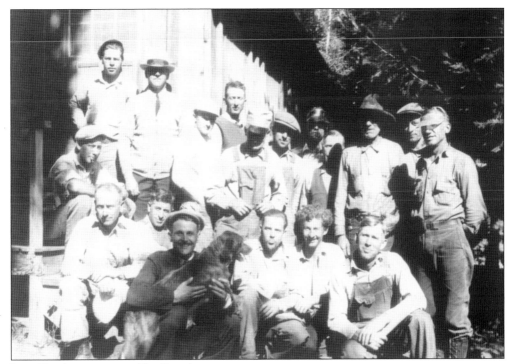

Lora Knight was inspired by Scandinavian fjords, Swedish stone churches, 11th-century castles, and Nordic carved doorways and decorations. Construction began during the summer of 1928, and by the following spring, more than 200 men were working on the property and housed in barracks. This crew of 18 unidentified men worked on building Vikingsholm. This photograph was made by Annie Miller Aikenhead. (Courtesy of California State Parks, Image No. 090-26054.)

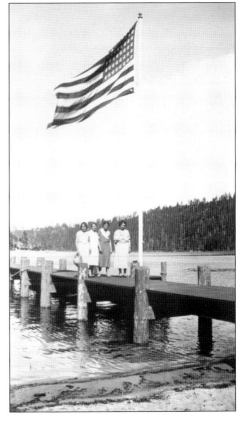

Four ladies, presumably members of Vikingsholm's staff, are photographed in the 1930s standing on the property's pier. The edge of Fannette Island is visible, left, at the end of the pier. Annie Miller Aikenhead, Lora Knight's personal maid, is second on the left. Annie Aikenhead was with Lora Knight at the Tahoe, Santa Barbara, and Reno homes and always accompanied her on trips. (Courtesy of California State Parks, Image No. 090-26034.)

Lora J. Knight was of English descent, born in Galena, Illinois, in 1864. In the 1880s, she married one of her father's law firm attorneys, James Moore, and they subsequently lived for a brief time in Santa Barbara. Six years after her husband died (1916), she married Harry French Knight, a St. Louis stockbroker. Together, they were the financial backers for Charles Lindbergh's flight across the Atlantic. (Courtesy of Helen Henry Smith.)

This August 16, 1953, photograph, made by John Shrawder, is of the dining room where everyone gathered for meals. Tea was served on the terrace, in the library, or occasionally in the teahouse on Fannette Island. Lora Knight would arrive in mid-June, bringing her staff from the winter home in Santa Barbara. The Vikingsholm style of living was lavish, gracious, and relaxed. (Courtesy of California State Parks, Image No. 090-27557.)

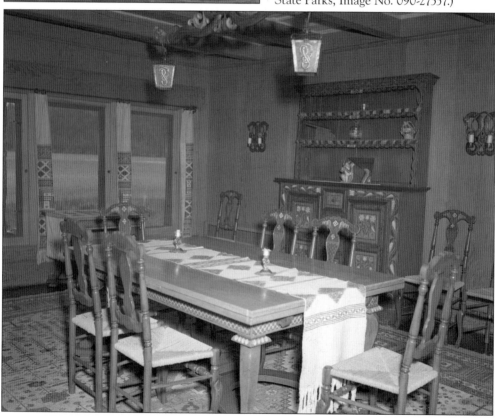

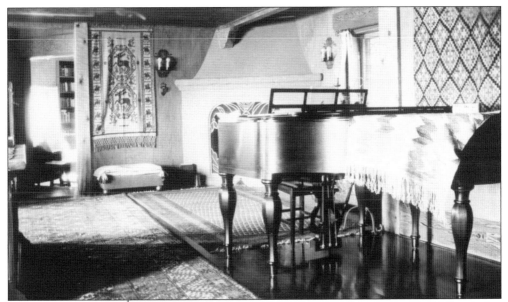

Lora Knight paid careful attention to the construction details and the furnishing of Vikingsholm. The fireplaces, including one mostly hidden by the piano in this 1930s Annie Miller Aikenhead photograph, were of Scandinavian design and feature unusual fireplace screens. These screens, designed by her architect Lennart Palme, and the metal latches were forged on site. (Courtesy of California State Parks, Image No. 090-26028.)

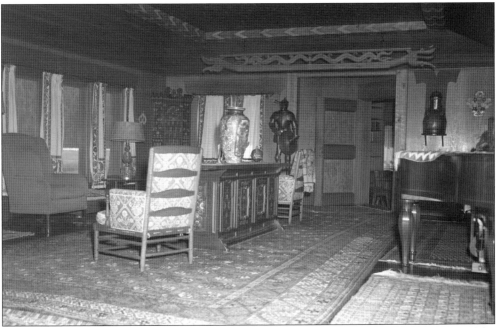

This August 16, 1953, photograph, made by John Shrawder, is of a different angle of a view of the living room in the previous image. The intricately carved dragon beams hang from the ceiling. Harvey West donated a suit of armor (page 46, bottom). The brightly colored "bridal table" is the central piece of furniture and historically highly valued by a married couple. (Courtesy of California State Parks, Image No. 090-27560.)

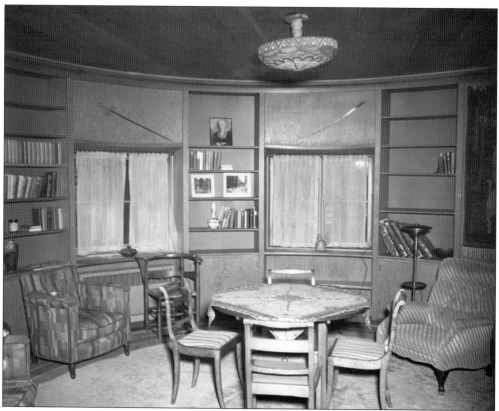

This August 16, 1953, photograph, made by John Shrawder, of the library at Vikingsholm was made in the year that the property was acquired as part of the Emerald Bay State Park. Harvey West, the philanthropist who donated one-half of the appraised value of the Vikingsholm estate, had already removed many of the books. (Courtesy of California State Parks, Image No. 090-27558.)

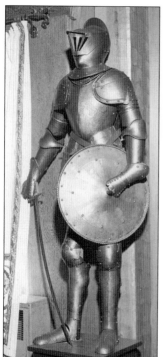

Harvey West, Vikingsholm's third owner, donated this suit of armor. The 12th-century count Adolf Von Soden wore the helmet and breastplate, and the child's suit of armor was worn by his weapon carrier, a 12-year-old boy. War was considered a prestigious activity, and well-crafted weaponry, including armor, were an important and conspicuous display of social status and political hierarchy. (Courtesy of California State Parks, Image No. 090-28072.)

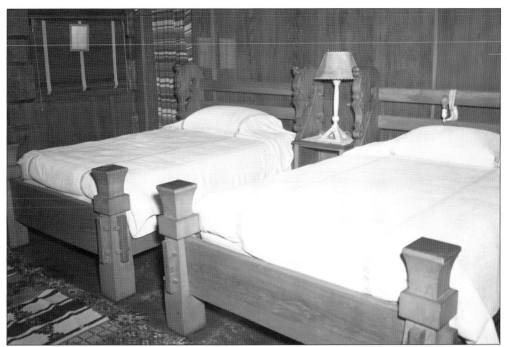

These twin oak beds on the sleeping porch are contemporary-sized replicas of a queen's bed found on a recovered Viking ship that had been on display in the Oslo Museum when Lora Knight visited there in 1928. Carved seahorse heads adorn both sides of the headboards. A cabinetmaker in Sacramento made the replicas. This August 16, 1953, photograph was made by John Shrawder. (Courtesy of California State Parks, Image No. 090-27556.)

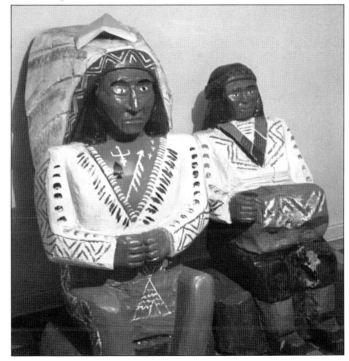

Harvey West introduced these Native American statues. Curios, artifacts, and other caricatures of Native Americans were more prevalent in less socially conscious times. The 19th- and early-20th-century carved wooden Indian was an advertisement for tobacconists. Indian statues depict common stereotypes when perceived outside of a carefully controlled historical context, portraying the "noble savage" with a stoic expression and passive stance. (Courtesy of California State Parks, Image No. 090-28226.)

Lora Knight commissioned Lennart Palme, a Swedish architect and her niece's husband, to design Vikingsholm. Together, they traveled to Scandinavia in the summer of 1928, visiting Denmark, Finland, and Norway looking for inspiration. They made photographs along the way, faithfully representing in Vikingsholm's features the detail of the original location's architectural identity. The timbers were hand hewn, and the carvings mimicked those found on old church entrances. In Scandinavian history, architectural elements reveal significant mastering of woodworking and engineering. These woodcarvings, derived from the pre-Christian art of the Vikings, are considered integral to the design and structure of the exteriors. The photograph at left was made by Jack R. Dyson; the photograph below was made by Norman Lee Wilson in July 1959. (Left, courtesy of California State Parks, Image No. 090-27868; below, courtesy of California State Parks, Image No. 090-27860.)

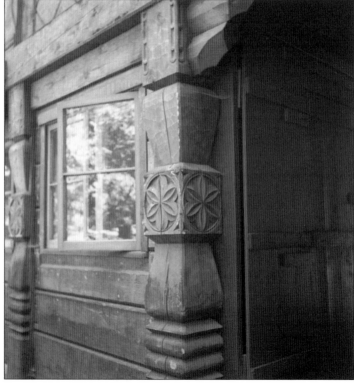

These exterior designs (right) are located in Vikingsholm's courtyard. Leroy Didsbury, known as "Happy," was a superb craftsman who made all the exterior woodcarvings, including these. The stylized and essentially decorative spikes protruding from the gutters are on the outside of the central courtyard buildings. These spikes reflect a custom practiced in early peasant homes where tree branches were shaped into spears and attached to houses to ward off evil spirits. Throughout the construction of certain sections of Vikingsholm, no nails, pegs, or spikes were used, consistent with construction practices in 11th-century Scandinavia. The photograph at right was made by Norman Lee Wilson on August 3, 1959; the photograph below was made by Jack R. Dyson in July 1959. (Right, courtesy of California State Parks, Image No. 090-27870; below, courtesy of California State Parks, Image No. 090-27861.)

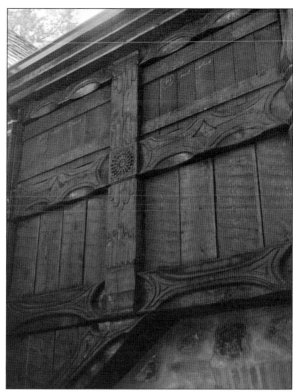

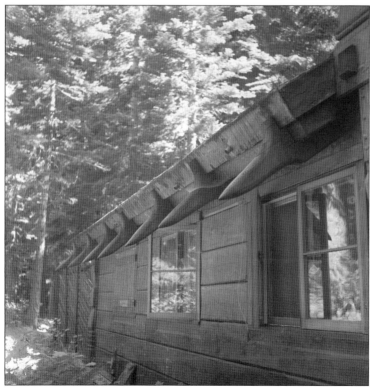

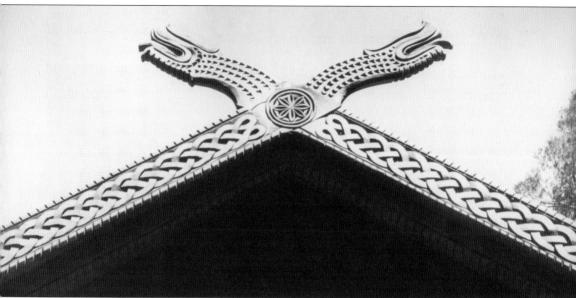

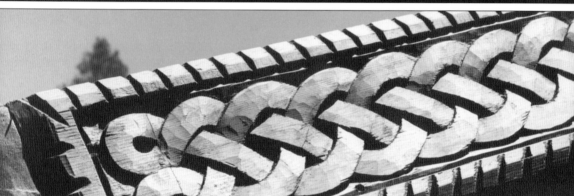

A noticeable adornment at Vikingsholm is the wood carved, highly stylized dragonheads that cross the roof peak (detail, lower photograph). The Vikings used the dragonheads on longships, usually carved into the prow, to protect the sailors on voyages. Dragons appear on stave churches typical in 12th-century Norway, usually but not always ornamental in design and function. When Christianity was introduced in the 11th century, practitioners hedged their beliefs by including dragonheads (similar to those found in heathen temples) on the Christian churches, providing added protection against evil. Similar gable heads appear on small houses common during that period. Those designs were symmetrical and had ridges and carved wood with vine and vegetal repeating patterns. In some cases, the dragons were used to facilitate drainage. (Top, courtesy of California State Parks, Image No. 090-28095; bottom, courtesy of California State Parks, Image No. 090-28096.)

Vikingsholm's interior courtyard is not visible from beyond the privacy of the contained architectural space, and many visitors are surprised to encounter the size of the living and working quarters. The egress, pictured here, is situated below the servant's quarters directly behind the main building, which faces the lake. The framing of the upper residences reveals more detailed woodcarving and the facade's decorative elements. (Courtesy of California State Parks, Image No. 090-28225.)

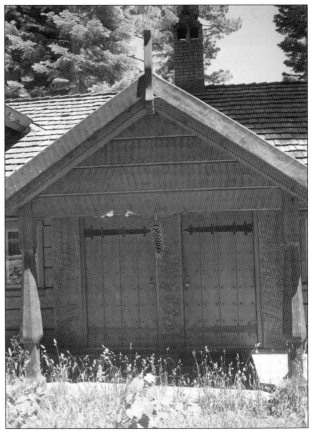

The extent of the decorative woodcarving is evident in the rear door along one of the exterior walls of Vikingsholm. The carving was accomplished using an adze tool, which is similar to an ax with an arched blade at right angles to the handle and used for cutting or shaping large pieces of wood. (Courtesy of California State Parks, Image No. 090-27538.)

Annie Miller Aikenhead is posing on the pathway leading north toward Emerald Bay camp. Emerald Peak is in the background. Annie Aikenhead was Lora Knight's personal maid. During the summers, as many as 15 people were on staff, including a personal maid, cook, assistant cook, upstairs and downstairs maid, chauffeur, assistant chauffeur, and laundry women. (Courtesy of California State Parks, Image No. 090-26035.)

Indian House was used to accommodate the overflow of guests when the upstairs bedrooms were fully occupied. The downstairs living room contained an amazing collection of Indian baskets. Similar baskets are valued in today's auction markets in the upper reaches of $250,000, and some were made by expert Indian weaver Dat-So-La-Lee, also known as Louisa Keyser. This photograph was made prior to 1958. (Courtesy of California State Parks, Image No. 090-27539.)

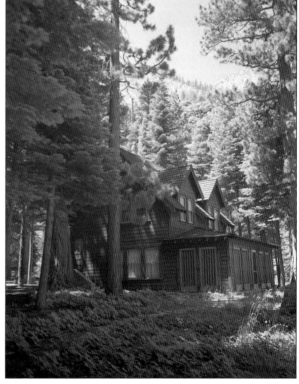

Lora Knight (center right), Helen Smith (right), and two unidentified friends are posing at Vikingsholm. Helen Smith's mother, Helen MacConnon Henry, and Lora Knight were friends; therefore, Helen Smith spent 14 summers at the estate. She was employed by the Department of Parks and Recreation for 45 years as a historian and tour director. During the 1990s, she established the Vikingsholm Restoration Project under the auspices of the California State Park Foundation. (Courtesy of Helen Henry Smith.)

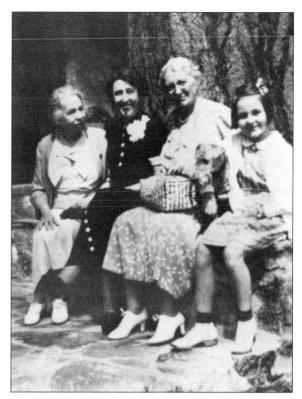

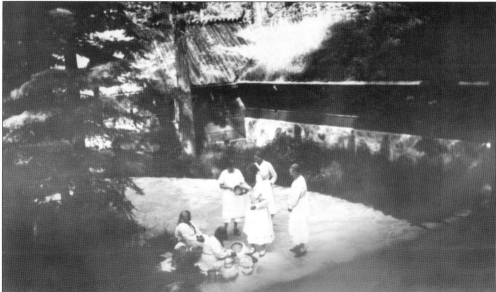

On their annual visit to Vikingsholm, Washoe women are displaying their wares to Lora Knight and others in the interior courtyard. After harvesting willow, sagebrush, tules, reeds, ferns, and other fibrous plants, the Washoe used the plants to expertly weave visually dynamic designs. The arts and crafts movement promoted a national appreciation of traditional native arts. This c. 1930s photograph was made by Helen Henry Smith. (Courtesy of California State Parks, Image No. 090-26078.)

Lora Knight is most remembered for Vikingsholm. However, her first property at Lake Tahoe was at Chinquapin, a sheltered cove in Carnelian Bay, slightly east of Dollar Point. Named Wychwood, it had stunning views, yet this view from Vikingsholm's living room of Fannette Island is the most unique view of all. This August 16, 1953, photograph was made by John Shrawder. (Courtesy of California State Parks, Image No. 090-27559.)

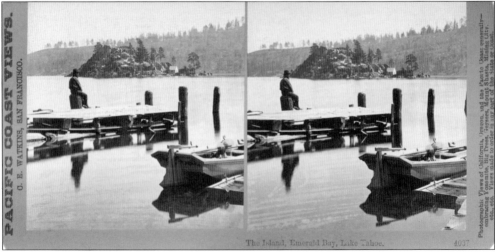

"The Island, Emerald Bay, Lake Tahoe" is not about the individual on the pier, although posing is Capt. Dick Barter, caretaker for Ben Holladay Jr.'s property before it became Vikingsholm. The foreground was purposely included as a compositional device, enabling a three-dimensional view when using a stereo viewer. Emerald Bay's visitors and homeowners have memorialized this view. This August 28, 1870, stereograph was made by Carleton Watkins. (Courtesy of the California State Library.)

The view "Lagoon in Front of Vikingsholm" was made from where the water from Eagle Falls meets Emerald Bay, very near Vikingsholm's main building, looking east at Fannette Island, Emerald Point, and beyond to Lake Tahoe. Although this photographer made a series of documents of the living and dining rooms, sleeping quarters, and artifacts of Vikingsholm, this image is unusual as it reflects the view that Lora Knight and guests enjoyed. The variability of the water flow and the consequences of years of runoff have changed the landscape such that the lagoon is occasionally dry. The terminus of Eagle Creek is essentially the location where the photograph was made. During the summer months, this area is generally packed with visitors, including a plethora of boats that drop anchor and other watercraft along the beach areas from one end of the property to the other. This August 16, 1953, photograph was made by John Shrawder. (Courtesy of California State Parks, Image No. 090-27545.)

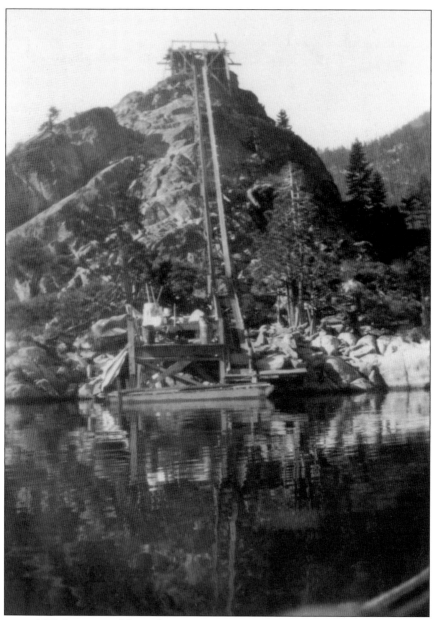

This is a rare 1930 document of the teahouse's construction on Fannette Island. During construction, heavy tar paper was laid on the affected areas so that no foreign materials would harm the natural features. The teahouse is part of the Vikingsholm experience, as it has always been connected to the construction of Vikingsholm and was one of the more unusual places Lora Knight enjoyed entertaining her guests. When high tea was scheduled on the island, yardmen and chauffeurs were positioned along the rough stone pathway to the summit in order to assist those needing help. Today, the site is only reachable via boat or other watercraft. After Lora Knight's death in 1945, the Vikingsholm estate, including Fannette Island, was purchased by lumberman Harvey West, who, in 1953, sold the land at 50 percent of the value to the State of California, enabling the creation of Emerald Bay State Park. (Courtesy of California State Parks, reference binder Emerald Bay State Park, Vol. 2, Image No. 5B-1a.)

Four

CABINS AND RETREATS

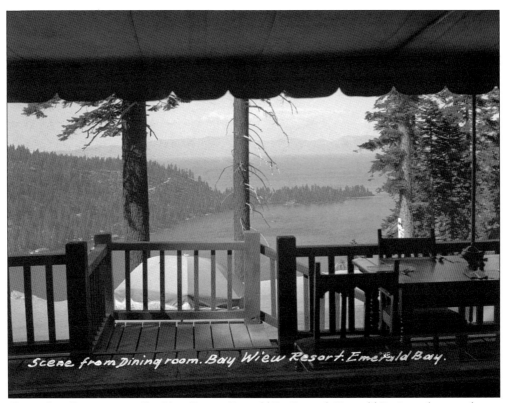

Scene from Dining room. Bay Wiew Resort. Emerald Bay.

"Scene from Dining room. Bay View Resort, Emerald Bay" reveals Emerald Bay's northern enclosure and Lake Tahoe beyond. The resort was a US Forest Service concessionaire and was located on the south side of Highway 89 and Emerald Bay. Offering lodging, dining, and a small store for groceries, souvenirs, and gasoline, the resort was not part of Emerald Bay State Park. (Courtesy of the Black Rock Institute.)

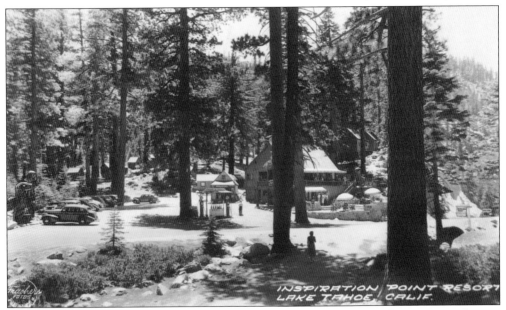

"Inspiration Point Resort, Lake Tahoe, Calif" was at one time the site of a US Forest Service ranger station. Inspiration Point, an overlook area, is across the highway. Today, the resort site is for overflow parking. In this photograph, there are totem poles amongst the tables, chairs, and umbrellas in front of the main building and to the left near the parked cars. This photograph was made by Burton Frasher Sr. (Courtesy of the Jill Beede Collection.)

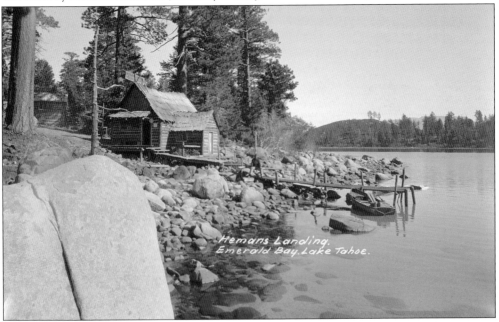

"Hemans Landing, Emerald Bay, Lake Tahoe" is on the northwest section of Emerald Bay Point. Hemans Landing was probably built by Metro-Goldwyn-Mayer studios for the filming of *Rose Marie*. According to a Cultural Resource Report of Emerald Bay completed in 1990, the signs "Hemans Landing" and "Trading Post" might have been added to reflect a sense of humor. (Courtesy of the Black Rock Institute.)

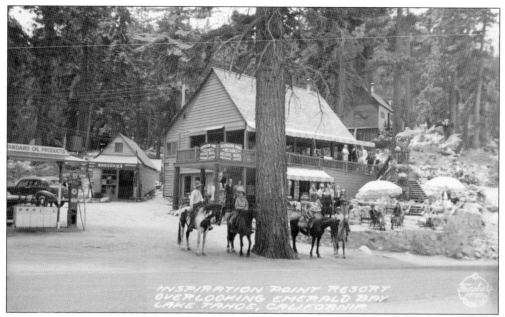

"Inspiration Point Resort Overlooking Emerald Bay, Lake Tahoe, California" offered the simulacrum of a real Western experience with rides on horseback with cowboys. Allegedly during the 1930s, this was the site of a Prohibition-era saloon. The totem poles derive from the movie *Rose Marie*. This photograph was made by Burton Frasher Sr. (Courtesy of the Jill Beede Collection.)

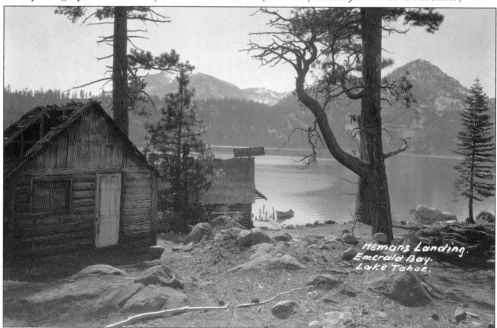

"Hemans Landing. Emerald Bay, Lake Tahoe" was pictured in the movie *Rose Marie*. The cabin was probably built as a set for the movie. Given that the photograph survives, Hemans Landing will forever reside in Lake Tahoe's visual history. Maggies Peaks are visible in the background. Today, the area where the cabins existed had been cleared and is overgrown with manzanita bushes. (Courtesy of the Black Rock Institute.)

This photograph is from the 1916 Lake Tahoe photographic shoreline survey. This small cottage, among a larger collection of cabins and cottages nearby, belonged to the William Henry Armstrong family. They acquired this property in 1895, using the cabins as their summer residence for more than 32 years, until 1928. This cottage was reportedly flooded by Lake Tahoe's waters, nearly 6,230 feet. (Courtesy of the North Lake Tahoe Historical Society.)

The William Armstrong family's compound at the southwestern end of Emerald Bay included cottages, a clubhouse, and a modest wharf. Daughter Jessie Armstrong named their family's approximately 200 acres as the Eden in the Sierra, and more specifically, Milfores. Paul and Lucy Kirby's ownership preceded the Armstrongs, and they had the T-shaped pier constructed in the mid-1880s. (Courtesy of Oliver Peter and the Peter Goin Collection.)

The July 16, 1916, shoreline survey crew is in action on their motorboat *Rip Van Winkle*. The view encompasses the end of the bay, between Dr. Hartland Law's and Margaret Jane Armstrong's properties. The western edge of Maggies Peaks and the gateway to the Desolation Wilderness are visible beyond the boat. (Courtesy of the North Lake Tahoe Historical Society.)

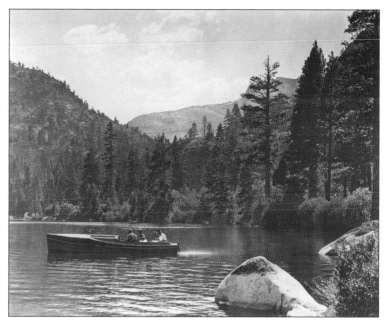

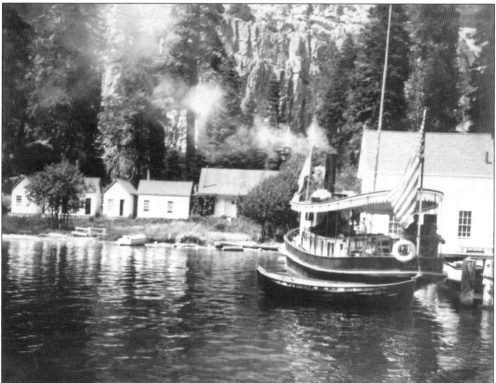

The *Tallac* (later renamed the *Nevada*) has its boilers steaming while still moored to the pier during this 1891 photograph. When Lora Josephine Knight purchased this property in 1928 from the Armstrong family, all the buildings and pier were removed. Today, this is a natural landscape under the jurisdiction of Emerald Bay State Park. (Courtesy of Oliver Peter and the Peter Goin Collection.)

This photograph, made by Herford Tynes Cowling, derives from the 1916 Lake Tahoe photographic shoreline survey and was made from Bradley's boat landing, pointing northeast showing low swampy ground. Charles Bradley was the school principal from San Francisco's Potter School Camp for Boys, which was located on the northwest point of Emerald Bay. (Courtesy of the North Lake Tahoe Historical Society.)

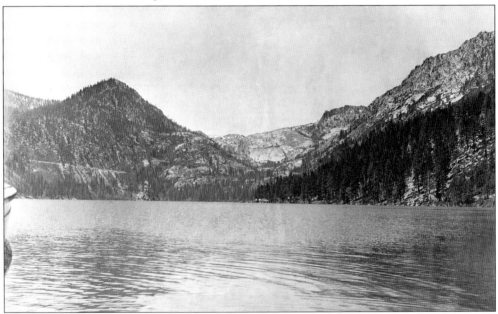

The starboard edge of the photographer's boat, the *Rip Van Winkle*, is visible at left. The boat was probably moored alongside Bradley's wharf. Maggies Peaks are in the distance. The nearly 200 photographs that have survived from the 1916 shoreline survey have provided valuable evidence of Lake Tahoe's ever-changing environment. This July 19, 1916, photograph was made by Herford Tynes Cowling. (Courtesy of Special Collections, University of Nevada, Reno.)

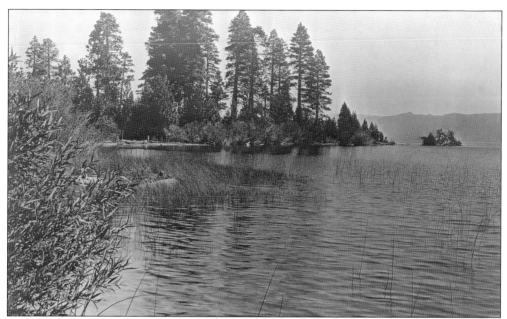

This photograph intersects the image at the top of page 62, basically creating a diptych. While the opposing page's image was made from Bradley's landing, this image was made from the lake's edge, just east of Bradley's landing looking toward Emerald Point and the bay. As of this view in 1916, the water elevation was 6,229.79 feet. This July 19, 1916, photograph was made by Herford Tynes Cowling. (Courtesy of the North Lake Tahoe Historical Society.)

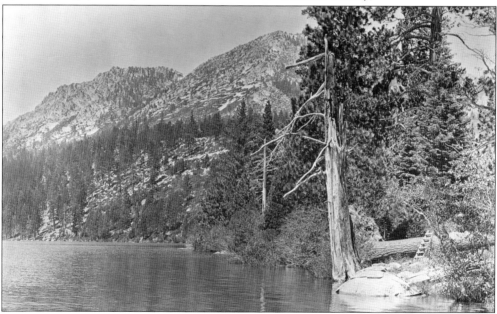

This photograph, from the 1916 Lake Tahoe photographic shoreline survey, was made from Bradley's boat landing approximately 40 feet from shore. The view southwest reveals the nature of the shoreline from Bradley's property to Russell Graves's property. Russell Graves and his wife, Lucy, Dr. Kirby's widow, operated the Emerald Bay Resort & Camp. This July 19, 1916, photograph was made by Herford Tynes Cowling. (Courtesy of the North Lake Tahoe Historical Society.)

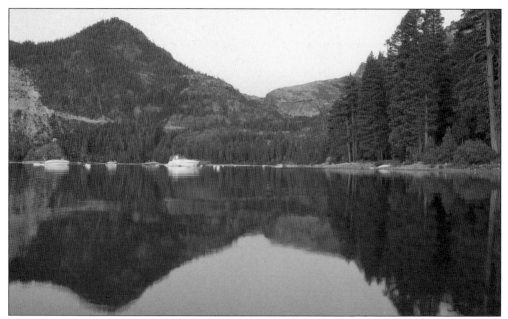

Nelson L. Salter owned Emerald Bay Camp from 1914 until 1947, when he sold the property to the California parks division. Emerald Bay Resort ceased operating in 1959, and the site was cleared. During 1963, the next vestige of Emerald Bay development appeared, the Emerald Bay Boat-In Camp, seen here in this 2010 photograph by Scott Hinton, coordinator of photographic research at the University of Nevada, Reno. (Courtesy of Scott Hinton.)

Herford T. Cowling, working with the 1916 Lake Tahoe photographic shoreline survey, made this July 19, 1916, photograph approximately 100 feet from where Eagle Creek intersected with Emerald Bay. At the time, the property belonged to the William Henry Armstrong family. Note the telephone pole in the lake's water. (Courtesy of the North Lake Tahoe Historical Society.)

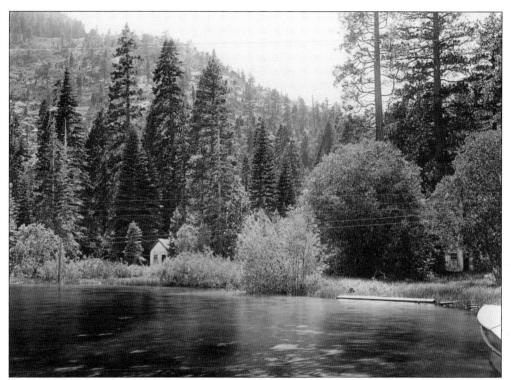

After the dam was completed at Tahoe City in 1913, the 1916 shoreline survey was an important data-gathering project documenting Lake Tahoe's rising waters. This view was made approximately 40 feet from shore on Margaret Jane Armstrong's boat landing at the west end. Today, as part of Emerald Bay State Park, this is a grassy picnic area. This July 19, 1916, photograph was made by Herford Tynes Cowling. (Courtesy of the North Lake Tahoe Historical Society.)

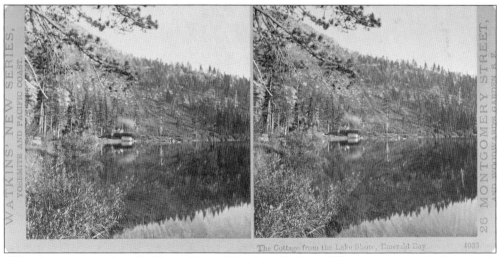

"The Cottage from the Lake Shore, Emerald Bay" is a Carleton Watkins stereograph that reveals in splendid three-dimensional viewing (with the appropriate stereo viewer) the site and location of Ben Holladay Jr.'s compound. Today, this landscape has mature second-growth forests and a walking path that connects to the Emerald Bay Boat-In Camp and, farther north, to the Rubicon Trail. (Courtesy of the California State Library.)

This Herford Tynes Cowling photograph from the 1916 shoreline survey was made from Charles Bradley's boat landing approximately 15 feet from shore. The view indicates Bradley's house on low ground; the lot is swampy and the house borders on flooding. This selective series of photographs from the 1916 Lake Tahoe photographic shoreline survey appear throughout this book. The photographic representation of Tahoe's spectacular scenery preceded scientific inquiry by nearly 60 years, yet most of the visual artifacts are vernacular fanciful memories, earnest recordings, and, while compelling, random collections of unidentified people and disjointed moments. Commercial photographs from more professional photographers are certainly part of the tale, but only one survey—the 1915–1916 shoreline survey—reveals a concerted, documented effort to record and portray Lake Tahoe. The 1915–1916 shoreline survey was initiated by the US Bureau of Reclamation primarily to document and provide evidence of the shoreline when the lake was at its maximum elevation. (Courtesy of the North Lake Tahoe Historical Society.)

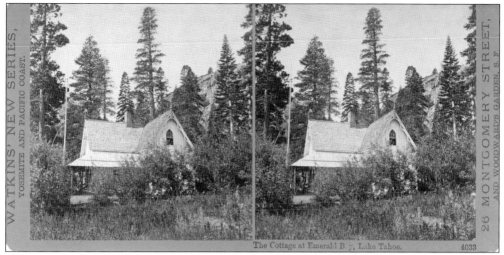

"The Cottage at Emerald Bay, Lake Tahoe" is a companion to the image at the bottom of page 65. This is a close-up view of the main house. Ben Holladay Jr. developed the first property at Emerald Bay in the late 1860s, and this villa was a two-story, five-room residence located on the southwest side of the end of the bay. This stereograph was made by Carleton Watkins in August 1870. (Courtesy of the California State Library.)

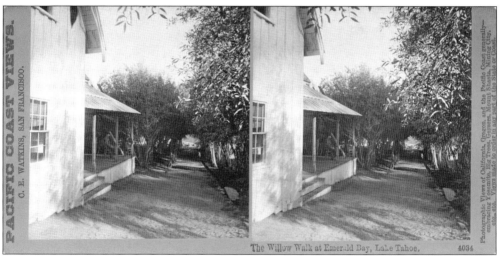

"The Willow Walk at Emerald Bay, Lake Tahoe" fronts the building's corrugated metal roofed porch. The walk leads to a boathouse and small wharf where Capt. Dick Barter kept several small skiffs in service of Ben Holladay's guests. John Eckley and his wife, Sarah E. Eckley, sold the property to Ben Holladay Jr. on August 15, 1868. This stereograph was made by Carleton Watkins in August 1870. (Courtesy of the California State Library.)

"Grazing at Armstrong's" is a vernacular photograph from an unidentified camper in the keepsake album titled Camp Chonokis 1932–1937. The camp's brochure promised to provide campers with all the joys and advantages of outdoor life and to promote interest in health, cooperation, sports, and nature. Its founders promoted ladylike conduct, keeping "manners high," while inspiring an appreciation for nature and ideals of conservation. (Courtesy of Special Collections, University of Nevada, Reno.)

"Stream at Armstrong's" is a vernacular photograph from the keepsake album Camp Chonokis 1932–1937. The stream connects Eagle Falls to Emerald Bay. Camp Chonokis, managed by Gladys Gorman, was created in part for well-to-do girls and to provide a safe haven during World War II. The white glare is simply an exposure flaw in the original black-and-white negative, dated 1936. (Courtesy of Special Collections, University of Nevada, Reno.)

In 1895, all but 120 acres of the original 500 acres from the Paul and Lucy Kirby family holdings had been sold to the William Henry Armstrong family. Margaret Jane Armstrong and her daughter Jessie named the property Milflores as they marveled at the plethora of wildflowers surrounding the cottages. The Armstrong family enjoyed Emerald Bay's alpine scenery for approximately 32 years. The photographs "Cooking at Armstrong's" and "Dishwashing at Armstrong's" derive from the Camp Chonokis album, 1932–1937. Camp Chonokis operated from 1927 to 1953 as a girls' camp for those from 8 to 18 years old. Mabel Winter and Ethel Pope established the camp approximately a half mile from the edge of Lake Tahoe at Stateline. Reflecting the alpine environment, the name *Chonokis* comes from the Washo language for "sugar pine." (Both, courtesy of Special Collections, University of Nevada, Reno.)

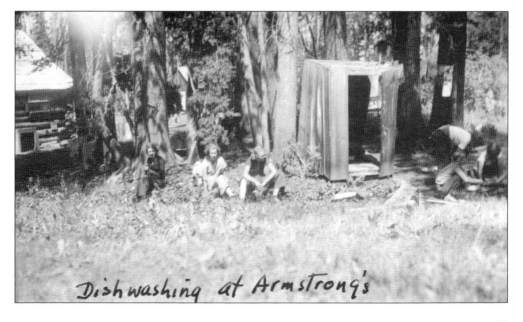

This Emerald Bay Camp, Lake Tahoe brochure advertises the resort but, surprisingly, from afar. The view, albeit a drawing, is from the northwestern ridge above the bay, showing in the distance Eagle Point and the passageway from Lake Tahoe into the bay. Emerald Bay Camp, also known as the Emerald Bay Resort & Camp, operated from 1881 until 1959. (Courtesy of the Lake Tahoe Historical Society.)

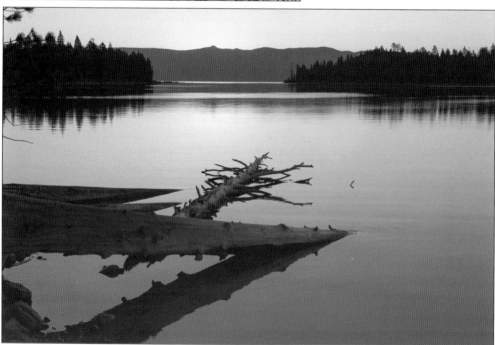

"Sunrise from Emerald Bay Boat Camp, Lake Tahoe" affirms the quintessential view of Emerald Bay's cardinal directions. The photograph was made long after Paul and Lucy Kirby, of Carson City, Nevada, purchased the 500 acres that became, in part, the Emerald Bay Camp that operated longer than any other resort in the Lake Tahoe area—78 years. This photograph was made by the author in 2013. (Courtesy of the Peter Goin Collection.)

Five

EMERALD BAY CAMP

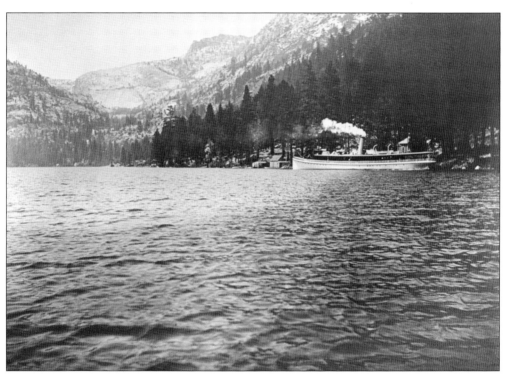

This 1899 view of the steamer SS *Tahoe* at Emerald Bay Camp was made from the water's surface. Following a series of land transfers due to government seizures and a sheriff's auction, Lucy Kirby acquired the land outright in 1884 and established the Emerald Bay Resort, including the original purchase with her husband, from 1881 to 1959. In 1962, Emerald Bay State Park was founded. (Courtesy of the Lake Tahoe Historical Society.)

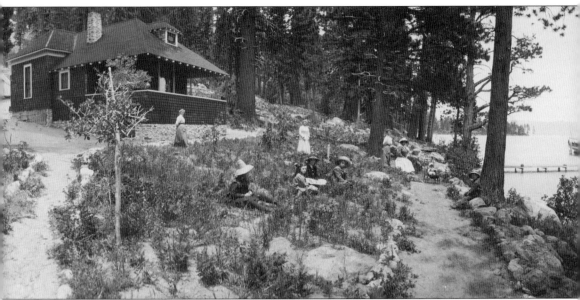

This c. 1910 "Emerald Bay, Lake Tahoe, Steamer at Pier" panorama was made by Harold A. Parker, photographer for the Tahoe Tavern, Tahoe City. People are posing throughout the view, the steamer *Tahoe* is moored at the pier for boarding passengers and baggage, and the resort thrives. In 1890, the *Sacramento Union* described Emerald Bay as a well-known vacation destination. At its most humble origins, the resort featured a small hotel with a large parlor and dining room,

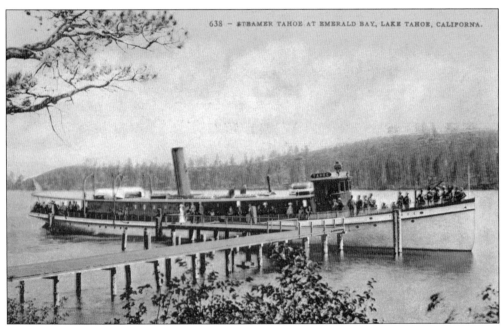

"Steamer Tahoe at Emerald Bay, Lake Tahoe, California" is a hand-colored postcard that is part of a series of views that were ubiquitously published. During the early years, Emerald Bay thrived with construction of a pier for the *Tahoe* steamer, gas pumps, and numerous buildings, including the 1888 Emerald Bay Post Office, which continuously operated until 1959. (Courtesy of Special Collections, University of Nevada, Reno.)

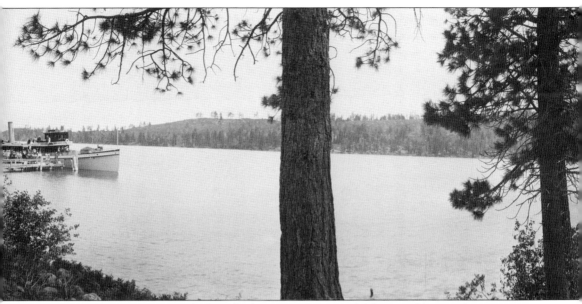

surrounded by numerous nicely furnished cottages. Boats and fishing tackle were free to guests, and the resort was replete with swings, hammocks, croquet, and recreational climbing sites, offering an abundance of outdoor exercise for enjoying nature. When the steamer era ended, the *Tahoe* was scuttled off Glenbrook. (Courtesy of Bill Bliss.)

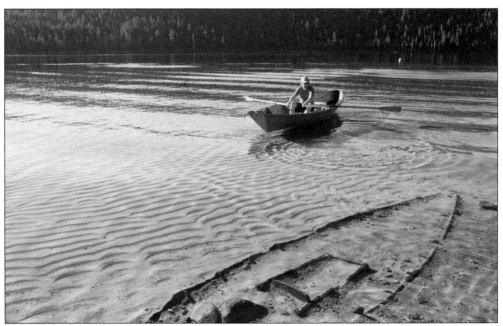

Scott Hinton, coordinator of photographic research at the University of Nevada, Reno, is seen departing Emerald Bay Camp the day after the second annual Dick Barter Regatta (a demonstration). This is the return voyage, whereby Hinton rows to the Tahoe Keys. The sunken boat is reminiscent of the Whitehall rowboat, known as a "bicycle of the sea." The author made this photograph in 2012. (Courtesy of the Peter Goin Collection.)

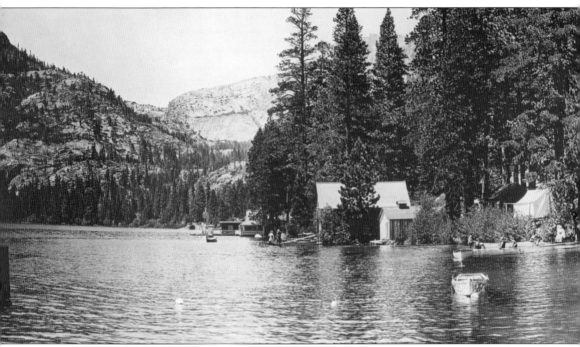

This shoreline survey photograph, made from the Emerald Bay Camp wharf about 75 feet from shore, documents the lakeshore conditions along Emerald Bay Camp. Dr. Hartland Law's house and boathouse are in the panorama's left center. In 1916, Dr. Law, of San Francisco, joined with Russell Graves and Nelson Salter to expand the steep road from the rim road around Emerald

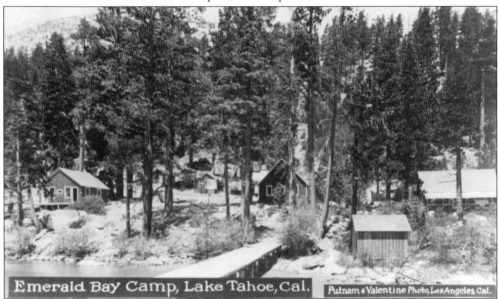

"Emerald Bay Camp, Lake Tahoe, Cal." is a view from the steamer *Tahoe* and is included in the Putnam & Valentine collection, which celebrates views of Lake Tahoe. John Putnam and Carleton Valentine operated their commercial photography business in Los Angeles, California, between 1898 and 1912. This photograph was probably made by John Putnam or his son Arion. (Courtesy of the Lake Tahoe Historical Society.)

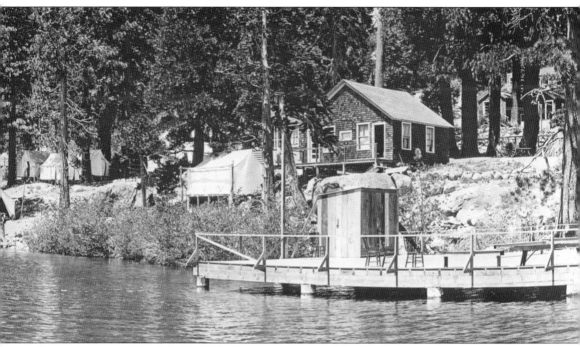

Bay to the resort. This July 19, 1916, photograph was made by Herford Tynes Cowling. The area is remarkably different today as the structures have been cleared and forest regrowth encouraged. (Courtesy of the North Lake Tahoe Historical Society.)

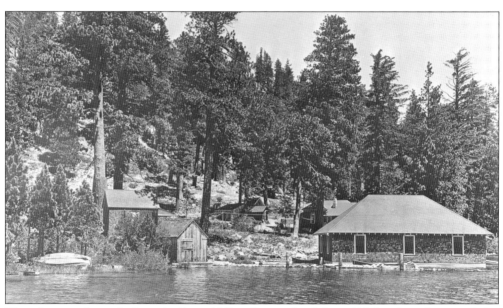

This photograph, made from the Emerald Bay Camp wharf about 100 feet from shore, includes Russell Graves's boathouse. At its peak, Emerald Bay camp had a total of 71 structures, eight were larger than 1,000 square feet, including four residence cabins, one soda fountain pavilion, dining room, boathouse, and storage barn. This July 19, 1916, photograph was made by Herford Tynes Cowling. (Courtesy of the North Lake Tahoe Historical Society.)

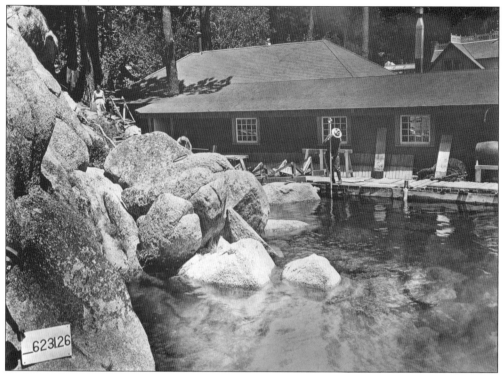

This view is from one of the shoreline survey boats approximately 50 feet from shore, fronting Dr. Hartland Law's property. Parson Rock is visible at left. The water level at this time was 6,229.79 feet. Today, this is one of the most popular campsites of the Emerald Bay Boat-In Camp. This July 19, 1916, photograph was made by Herford Tynes Cowling. (Courtesy of Special Collections, University of Nevada, Reno.)

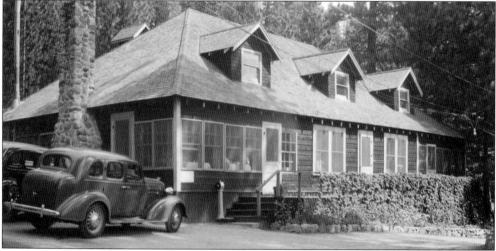

Seen in 1936, Emerald Bay Camp's hotel was centrally located. A few segments of the rock wall facades are still visible today. The camp featured electrical lighting throughout and could accommodate 150 people in a variety of tents, cottages, and cabins, some with, and some without, a bath. The floor tents had carpeted floorboards. Long distance telephone, telegraph, and daily mail and express service were advertised. (Courtesy of the Jill Beede Collection.)

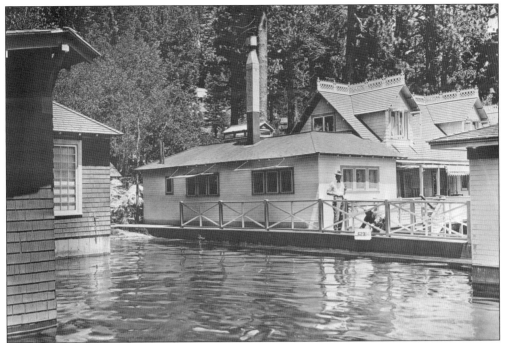

This view, part of the 1916 shoreline survey, is from Dr. Hartland Law's boathouse wharf, approximately 30 feet from the shore. The house was constructed as an extension over and above the lake; note the steep sloping hillside behind the development. Dr. Law owned approximately two acres. This July 19, 1916, photograph was made by Herford Tynes Cowling. (Courtesy of Special Collections, University of Nevada, Reno.)

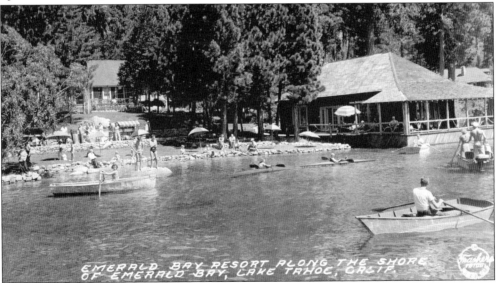

"Emerald Bay Resort Along the Shore of Emerald Bay, Lake Tahoe, Calif." is a Frasher Fotos postcard, and one of the most representative photographs of Emerald Bay Boat-In Camp. The exact view today would be made from the current pier. The rock where the two boys are standing is still there; although, the rest of the landscape has dramatically changed. (Courtesy of the North Lake Tahoe Historical Society.)

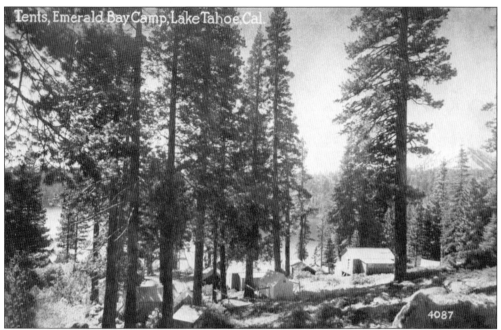

This c. 1920 "Tents, Emerald Bay Camp, Lake Tahoe, Cal." is viewed from the higher slopes. The site boasted 7 cottages, 6 housekeeping cottages, 8 cabins, 2 storage rooms, 5 sheds, 2 restrooms, and 22 tents. Each tent was supplied with a double iron bedstead, bedsprings, top mattress, dresser, pillows, blankets, clean linen, washstand, chairs, and crockery; completely furnished just as a hotel room would have been. (Courtesy of the Nevada Historical Society.)

Verner and Cora Adams and an unidentified man are posing around 1926 in front of "Emerald Bay Camp and Hotel." The hotel was advertised as the "most beautifully situated hotel camp in the region." The nearly mile-long newly paved road connected the resort to the state highway, and there was no charge for "parking machines." Gas and oil were available on site. (Courtesy of Special Collections, University of Nevada, Reno.)

"Emerald Bay Camp Lake Tahoe, Cal." is a rare view of both regular and canvas-backed benches ready for evening parties. For those desiring to do their own housekeeping, tents and complete camping outfits were available. The streams and lakes were stocked with Eastern brook, Loch Leven, and cutthroat trout. Hiking, swimming, and sightseeing were promoted. (Courtesy of the Black Rock Institute.)

"Emerald Bay Resort Lake Tahoe California," nestled in a sheltered inlet amongst a grove of pines and cedars, featured informal dances in the evenings, candy pulls, corn pops, and roaring fires with an orchestra serenading campers who brought and played their own musical instruments. A fully equipped darkroom was a special opportunity for guests who fancied themselves photographers. (Courtesy of the Black Rock Institute.)

Just as it is today, visitors to Emerald Bay State Park enjoy the tranquil beauty, relaxing atmosphere and the refreshing activities the area provides

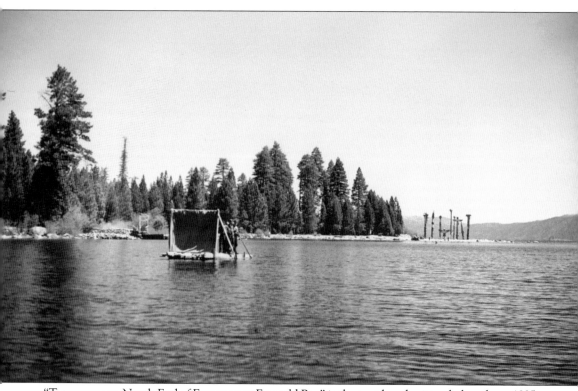

"Totems are on North End of Entrance to Emerald Bay" is the text handwritten below the c. 1935 photograph. Merging the experience of Emerald Bay Camp with the next chapter, unidentified individuals constructed a rudimentary floating raft and managed to embark on a journey to investigate the totem pole landscape at Emerald Point. The scene at the northeastern end of the bay is from the Metro-Goldwyn-Mayer studios production set for the movie *Rose Marie*. Filmed during summer and fall of 1935, the movie starred Jeanette MacDonald and Nelson Eddy. Directed by W.S. Van Dyke, *Rose Marie* was adapted from the 1924 Broadway musical. *Rose Marie* opens in Montreal, Canada, where celebrated opera soprano Marie de Flor (Jeanette MacDonald) pleads to Canada's premier to release her younger brother John Flower (Jimmy Stewart), convicted for bank robbery. She learns that he killed a policeman during a breakout, fleeing into the wilderness. With her Indian guide Boniface (George Regas), she searches for her brother. On his trail is a handsome Canadian Mountie, Sergeant Bruce (Nelson Eddy). (Courtesy of California State Parks, Image No. 090-27347.)

Six

ROSE MARIE, THE MOVIE

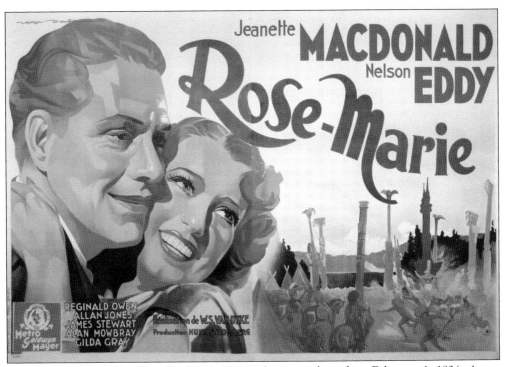

Rose Marie, directed by Woodbridge S. Van Dyke, was released on February 1, 1936. As an exploitation stunt, the studio offered $2,000 to the first woman in 1936 to name her newborn twin daughters "Rose" and "Marie." The prize was awarded to Mrs. Esker R. Owens, of Fort Smith, Arkansas. The movie is a caricature of happy endings and objectified Indians as well as the setting. (Courtesy of the Peter Goin Collection)

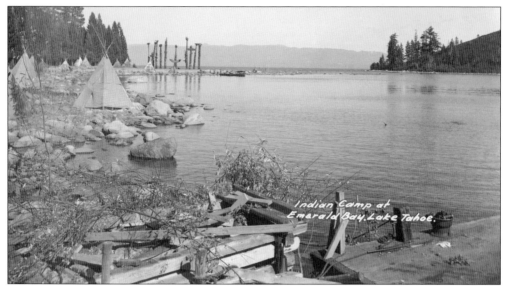

"Indian Camp at Emerald Bay, Lake Tahoe" (above) and "Indian Totem Poles, Lake Tahoe" (below) document the stage set for the movie *Rose Marie*. Director W.S. Van Dyke considered Lake Tahoe's landscape an ideal representation of the Canadian wilderness. Metro-Goldwyn-Mayer studios' production teams transported eight railcars of equipment and props to Emerald Point with the stars, crew, and more than 300 "Indian" extras. These extras included 90 trained dancers, and everyone was housed in 300 tepees built along the lakeshore between Emerald and Rubicon Points. The dancers were trained in Hollywood to do the Canadian "Corn Dance," which was filmed on location. (Above, courtesy of the North Lake Tahoe Historical Society; below, courtesy of the Black Rock Institute.)

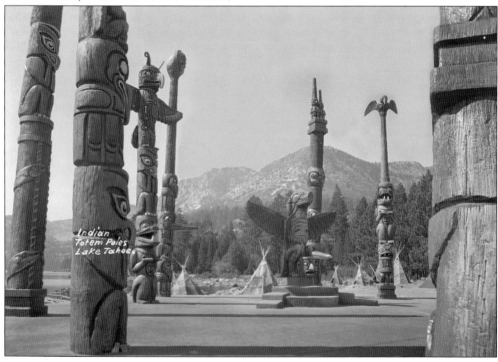

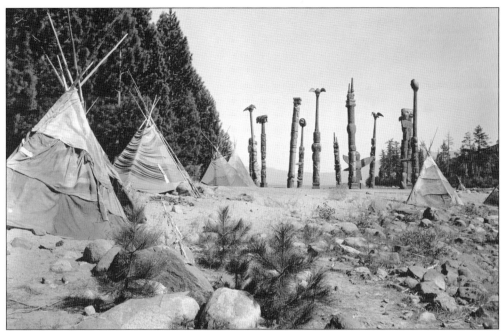

The tepees and totem poles on location for *Rose Marie* (1936) and "Indian Totem Poles, Lake Tahoe, Emerald Bay" are memorialized throughout Lake Tahoe as a few totem poles, and suitable facsimiles, decorate lakefront homes. Marie de Flor (Jeanette MacDonald) is double-crossed, robbed of her life's savings, and dumped by her hired guide, so she is forced to accept a job singing in a bawdy dance hall saloon in order to survive. Her refined soprano voice is out of place in a saloon where the uncouth patrons heckle her. She receives advice from one of the other entertainers, Bella (Gilda Gray), who teachers Marie to keep her job by vulgarizing her act. As she performs, Sergeant Bruce, a Canadian Mountie, enters and, in the grand tradition of the mounted police, rescues her. (Both, courtesy of the Black Rock Institute.)

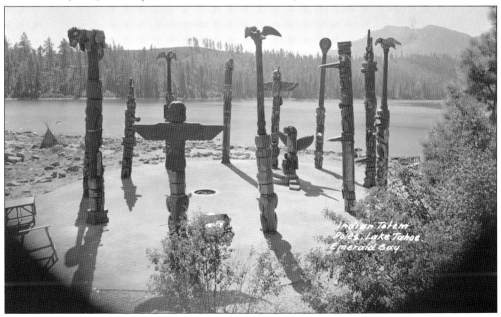

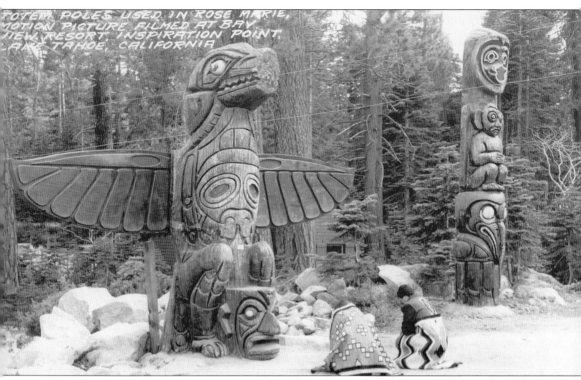

This photograph is titled "Totem poles used in Rose Marie, Motion Picture Filmed at Bay View Resort, Inspiration Point, Lake Tahoe, California." *Rose Marie* spawned postcards and an enduring connection to Lake Tahoe. Images of the movie, although fictionally set in Canada's wilderness, create a faux sense of Lake Tahoe's exotic nature. The two Indians devoutly kneeling in front of the totems are wearing Navajo blankets, reflecting the diffusion amongst tribal identities. MGM's Campaign Book's publicity noted that the "Totem Pole Dance" sequence was filmed in six weeks and featured more than 700 Indians from 50 different tribes, apparently a dramatic exaggeration given numerous and differing versions (refer to top photograph, page 82). Consistent with the times, the movie reflects inherent biases toward Indians. Marie's Indian guide Boniface is untrustworthy, and Indians are represented as stereotypes throughout the movie. An October 1935 *Daily Variety* news item read that "hundreds of totem poles" that were used on the Lake Tahoe set were donated to the state park bordering the lake. This allegation cannot be confirmed; however, a few totems can still be seen on lakefront estates. (Courtesy of the North Lake Tahoe Historical Society.)

This publicity still promoted the chemistry between stars Jeanette MacDonald and Nelson Eddy. However, the marketing of Lake Tahoe was an unintended and enduring consequence. Sergeant Bruce (Nelson Eddy), in love with Marie, learns that the fugitive (Jimmy Stewart) is her brother. Following his sworn duty to apprehend the escaped convict, Sergeant Bruce secretly trails them, providing the stage for the inevitable romance. (Courtesy of the Lake Tahoe Historical Society.)

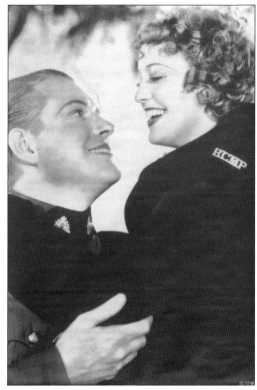

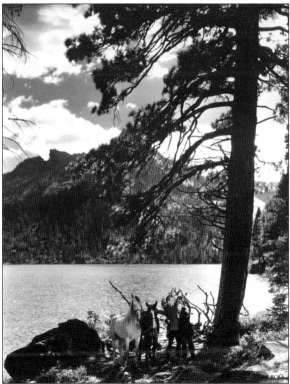

As the film's plot evolves, Sergeant Bruce arrests Marie's brother and returns him to justice. Marie, distraught, returns to her role as an opera star where she suffers a dramatic nervous breakdown. During her convalescence, trusted friends send for her true love, Sergeant Bruce, who returns to her side. In a noteworthy love scene, they deliver their glorious duet, "Indian Love Call," together. (Courtesy of the Lake Tahoe Historical Society.)

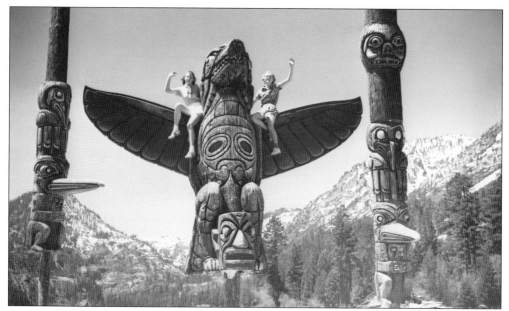

Two unidentified ladies wave from atop one of nine totem poles at Emerald Bay Point. The totems were part of the set for *Rose Marie*. Totem poles were used to solidify Lake Tahoe as an Canadian landscape in the movie's narrative. In North America, totem poles serve many purposes, representing identity, important events, legends, and family genealogy. (Courtesy of California State Parks, Image No. 090-27351.)

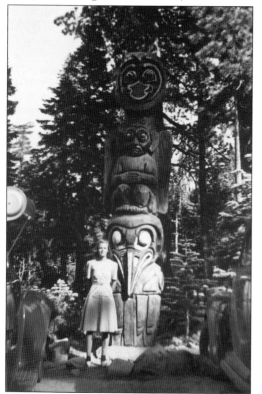

"Mary McGregor standing in front of a totem pole, Emerald Bay, California, 1941" attests to the survivability of *Rose Marie*'s totem poles after filming concluded. Mary McGregor was the daughter of Janet and Frank W. McGregor. She married Elmore H. "Bud" Alwes, and together, they had three children, Bill, Bonnie, and Janet. This totem pole was one of many fabricated for the drum scene. (Courtesy of the Sonoma County Library.)

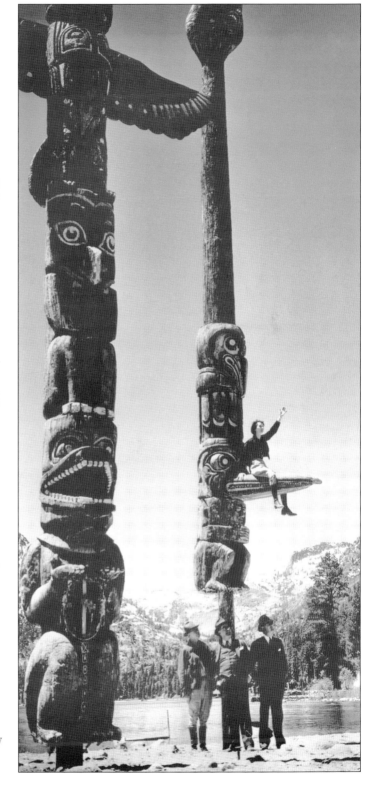

"Mr. Snook Standing in front of Two Totem Poles" places into context Emerald Bay's scenery for the movie *Rose Marie*. Hanes A. Snook was the chief and director of the California Division of Beaches and Parks (1935–1936). To avoid confusion with the 1955 remake of *Rose Marie*, the 1936 Rose Marie was retitled *Indian Love Call* for television distribution. Other notable films feature the lore of Tahoe, including Buster Keaton's *The Navigator* (1924), whereby Lake Tahoe was the ocean near Catalina Island, and Charlie Chaplin's *The Gold Rush* (1925), which presented Donner Summit as an Alaskan locale. *Call of the Wild* (1935) also transformed Tahoe into Alaska scenery. Elizabeth Taylor and Montgomery Clift starred in *A Place in the Sun* (1951), where Tahoe was the fictional Loon Lake. The most well-known Tahoe-made film, *The Godfather: Part II* (1974), was filmed at the summer estate of Henry J. Kaiser, now the Fleur du Lac condominiums. (Courtesy of California State Parks, Image No. 090-27344.)

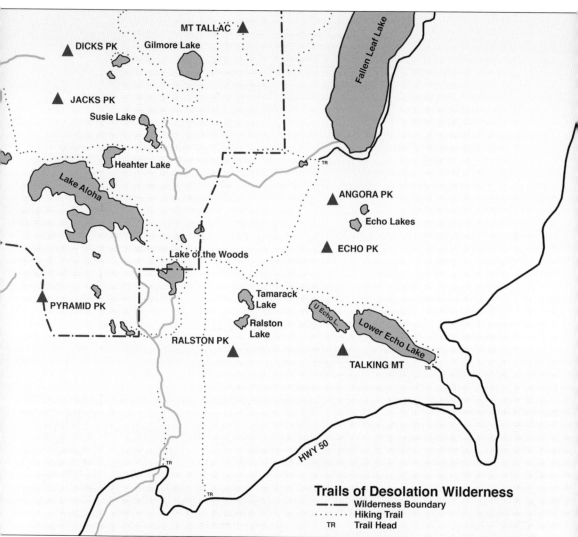

MT TALLAC
DICKS PK
Gilmore Lake
Fallen Leaf Lake
JACKS PK
Susie Lake
Heahter Lake
Lake Aloha
ANGORA PK
Echo Lakes
ECHO PK
Lake of the Woods
Tamarack Lake
PYRAMID PK
Ralston Lake
RALSTON PK
U Echo L.
Lower Echo Lake
TALKING MT
TR
HWY 50
TR
TR
TR

Trails of Desolation Wilderness
—·— Wilderness Boundary
· · · · · Hiking Trail
TR Trail Head

The original "Desolation Wilderness—Proposed" map, dated April 26, 1967, accompanied the bill to designate what is today the Desolation Wilderness. Public Law No. 91-82, in accordance with the Wilderness Act of September 3, 1964, identified the area previously classified as the Desolation Valley Primitive Area as the official Desolation Wilderness within and as part of the Eldorado National Forest, California. The management of the wilderness falls within the Department of Agriculture, thereby insuring that the owners and operators of existing federally licensed hydroelectric facilities shall have reasonable access to the areas in order to maintain their facilities. The law was approved on October 10, 1969. The Desolation Wilderness includes 63,960 acres of subalpine and alpine forests, granite peaks, and glacially formed lakes and valleys. Prior to this act and the identification of this area as the Desolation Valley Primitive Area, the landscape within the newly formed Desolation Wilderness was part of the Lake Tahoe Forest Reserve, established in 1899. (Illustration by Scott Hinton; courtesy of the Peter Goin Collection.)

Seven
DESOLATION WILDERNESS

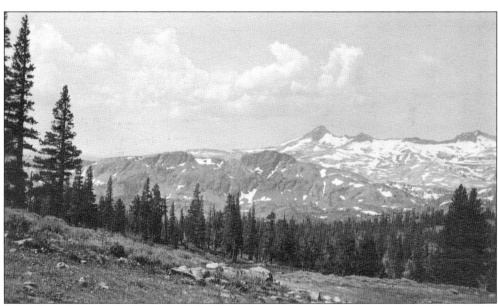

One of Desolation Wilderness's sentinel peaks is Pyramid Peak, center. Named after its unmistakable shape, this peak within the Crystal Range can be viewed from the Coastal Range. Within the Desolation Wilderness, Pyramid Peak has the highest elevation (9,983 feet), and for hikers, the 23 percent grade over the last three miles presents an arduous workout. This 1935 photograph was made by an unidentified hiker from Camp Chonokis. (Courtesy of Special Collections, University of Nevada, Reno.)

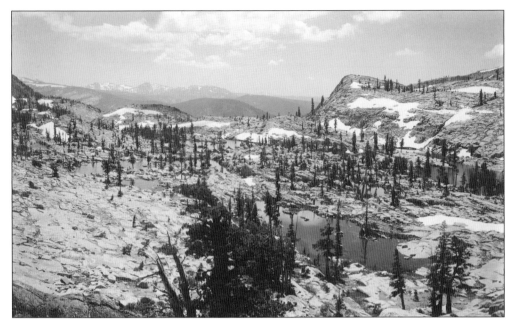

The Wilderness Act of 1964 initially designated nine million acres, including the Desolation Wilderness, as part of the National Wilderness Preservation System. Since this act became law, more than 100 million additional acres of federal public lands have been preserved as wilderness. This c. 1916 view looking south includes American Lake and Channel Lake, both within the Desolation Wilderness. (Courtesy of the California History Room, California State Library, Sacramento.)

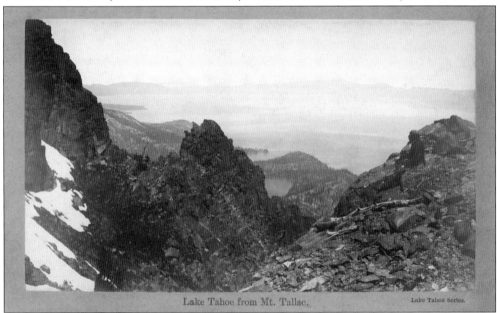

"Lake Tahoe from Mt. Tallac" is from R.J. Waters's *Lake Tahoe Series*. The edge of Emerald Bay and a larger portion of Cascade Lake are visible, center. Unparalleled views are perennially available at the summit of Mount Tallac (9,735 feet). The hiking route involves a 3,500-foot elevation gain, passing through lush forests, past alpine lakes, and through colorful wildflower meadows. (Courtesy of the Lake Tahoe Historical Society.)

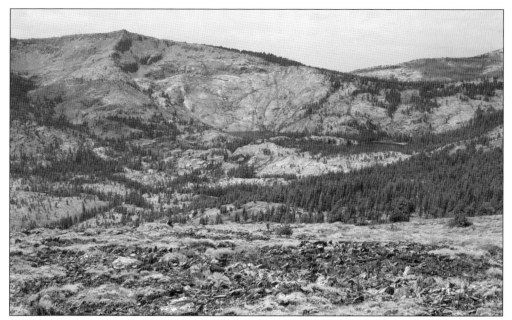

"Ralston Peak as seen from Echo Peak, El Dorado National Forest, California" embraces recent National Park Service efforts to identify high-value viewsheds that provide a greater context for the wilderness experience. Although areas outside of the Desolation Wilderness are managed differently, they are integrated visually. Ralston Peak (9,235 feet) is on the southern boundary of the Desolation Wilderness. This photograph was made by Scott Hinton. (Courtesy of Scott Hinton.)

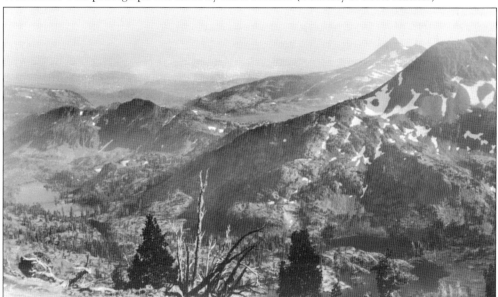

This hazy view from an impressive outlook near Dicks Peak aims south across the Desolation Wilderness landscape. Susie Lake is at the lower left of the photograph. Continuing an ever-present tradition of reevaluating and redefining the management jurisdiction of alpine landscapes, the Desolation Valley Primitive Area was established in 1931. This 1930 photograph was made by an unidentified hiker from Camp Chonokis, a summer camp for girls that operated at Lake Tahoe from 1927 through 1953. (Courtesy of Special Collections, University of Nevada, Reno.)

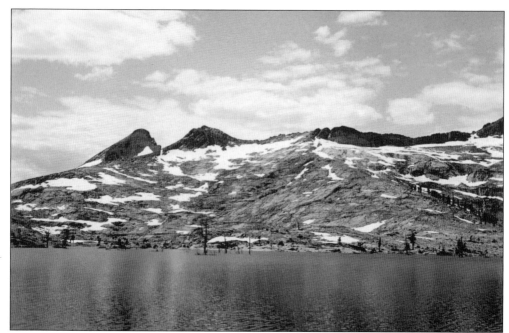

This 1932 photograph was titled "Desolation" rather than "Desolation Wilderness" by an unidentified hiker from Camp Chonokis. Pyramid Peak anchors the image at left, and combined with the image on the next page, a modified panorama emerges. (Courtesy of Special Collections, University of Nevada, Reno.)

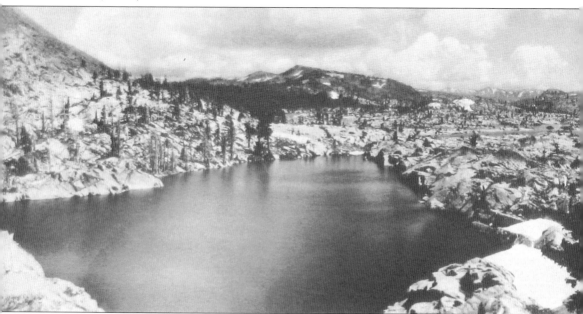

Lake LeConte is a relatively small alpine lake located just east of the much larger Lake Aloha. The lake was named after a professor of geology, Joseph LeConte (1823–1901), at the University of California, Berkeley. Professor LeConte was an early California conservationist and served as president of the American Association for the Advancement of Science in 1892 and also of the Geological Society of America in 1896. He explored the Sierra Nevada, became friends with

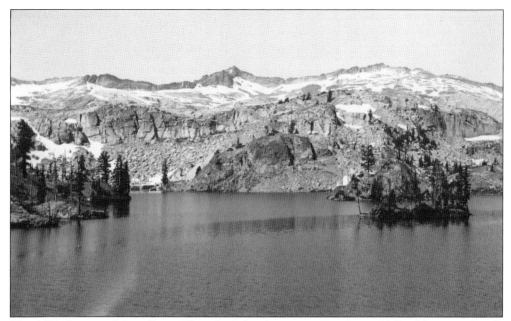

This 1932 photograph by a Camp Chonokis hiker documents Desolation Valley. The name *Devil's Basin* first described and identified this landscape on the Wheeler map of 1881, US Geological Surveys West of the 100th Meridian. The name *Devil's Basin* derived not from a literal reference to the Devil but to the wild and allegedly uncharted terrain, beautiful and sublime. (Courtesy of Special Collections, University of Nevada, Reno.)

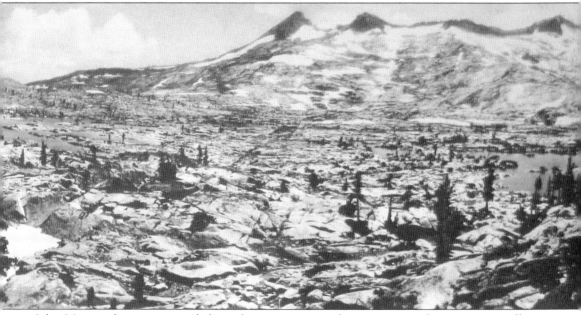

John Muir, and was concerned about the consequences that resource exploitation, especially sheepherding, would have in alpine environments. He wrote "Ancient Glaciers of the Sierra" and "Ramblings Through the High Sierra" published in the *American Journal of Science and the Arts* and *Sierra Club Bulletin No. 3*, respectively. (Courtesy of the Lake Tahoe Historical Society.)

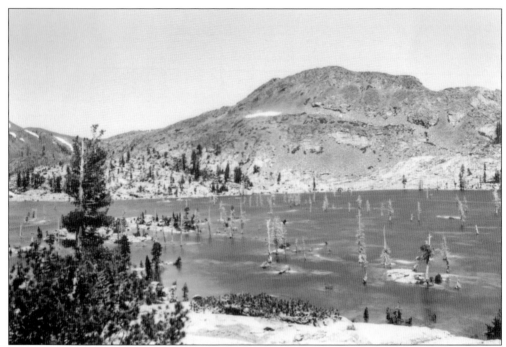

"Desolation Valley" was a frequent destination for Camp Chonokis's hikers, and the camp's photo album provides a unique albeit unintentional photographic survey of the Desolation Wilderness. Preservation of Desolation Valley began in earnest during 1910 when the El Dorado National Forest was created. The Desolation Valley Primitive Area was set aside in April 1931 and included 41,383 acres. (Courtesy of Special Collections, University of Nevada, Reno.)

This 1946 photograph's title, "Desolation Valley," which is similar to most of the Camp Chonokis album photographs, refers to a large area that is now Lake Aloha. Desolation Wilderness, 6 to 8 miles wide, 15 miles long, and nearly 100 square miles in total area, is one of the most heavily visited wilderness areas in California. (Courtesy of Special Collections, University of Nevada, Reno.)

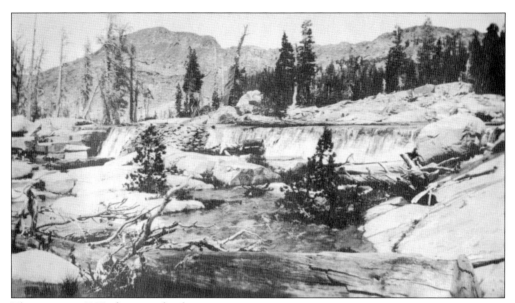

This is a rare 1930 photograph of a small dam in Desolation Valley. This area features subalpine forests, jagged granite peaks, and glacially formed lake basins. The wilderness consists of countless streams and 130 lakes as elevations range from 6,500 to nearly 10,000 feet. The Pacific Crest Trail includes the entire length of the wilderness along a north-south corridor. (Courtesy of Special Collections, University of Nevada, Reno.)

The 1935 trail through Desolation Valley has become one of the most heavily trafficked loops throughout the Desolation Wilderness. In order to protect its unique beauty and wilderness character, human access is limited, fires are prevented, vehicles are prohibited, and permits are required. Desolation Wilderness has 45 zones that are accessed by any of 15 trailhead entry points. (Courtesy of Special Collections, University of Nevada, Reno.)

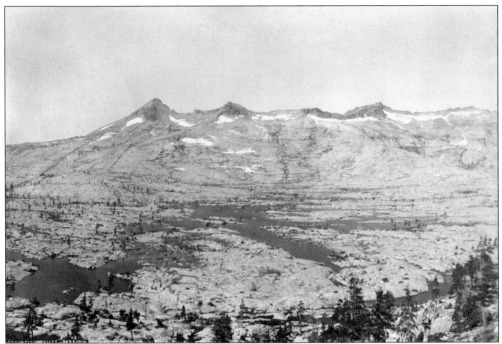

The landscape fronting Pyramid Peak was under the jurisdiction of the Lake Tahoe Forest Reserve (1899) and the Eldorado National Forest (1910). When this photograph was made in the 1920s, the area was known as the Desolation Valley and later, after dams restricted its waters, Lake Aloha. Once that happened, Lake Aloha became the largest lake complex in the Desolation Wilderness. (Courtesy of the North Lake Tahoe Historical Society.)

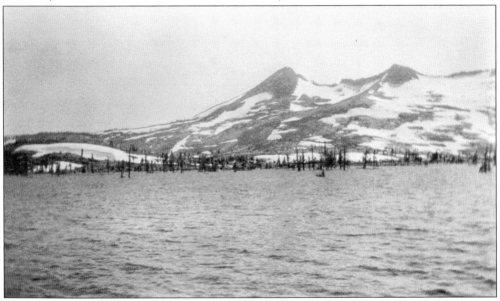

Pictured in 1930, Lake Aloha is actually a chain of lakes merged into a single larger lake through the damming of their waters. Lake Aloha features shallow, clear water sitting in a wide, granite basin carved by glaciers. Horsetail Falls, which tumbles in stages for nearly 500 feet, is just one of the area's many waterfalls. (Courtesy of Special Collections, University of Nevada, Reno.)

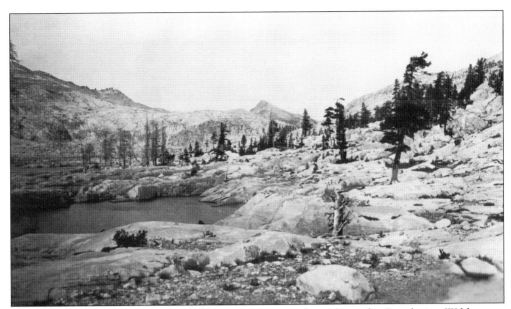

There is evidence of temporary Washoe encampments throughout the Desolation Wilderness, including the landscapes surrounding Lake Aloha, as pictured here in 1930. The Washoe groups moved through the area on their summer migration from the Carson Valley. Artifacts such as obsidian arrow points and other evidence, while not abundant, have been documented. The area incorporating the Desolation Wilderness has a history of Euro-American use dating back to the 1800s. Gold miners explored the granite mountains and drainages but found only a few low-grade ore deposits. Cattle were grazed in the Haypress Meadows area from the 1850s to the 1930s. Hikers and backpackers populate the wilderness now. (Above, courtesy of Special Collections, University of Nevada, Reno; below, courtesy of the North Lake Tahoe Historical Society.)

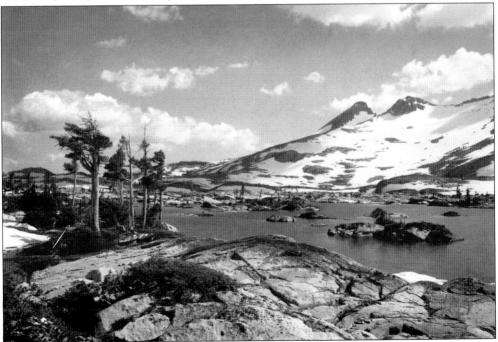

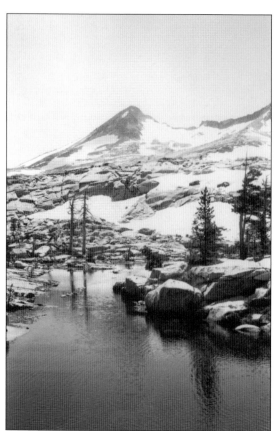

Lake Aloha's scenery reflects iridescent blue waters in dramatic contrast to the sheer granite walls of the Crystal Range peaks. This area is a photographer's paradise, although during the 2016–2017 winter season, Desolation Wilderness experienced higher-than-average snowfall. As of mid-July, areas above 8,300 feet still retained snow, and some lakes remained frozen. This photograph was made in 1946. (Courtesy of Special Collections, University of Nevada, Reno.)

In 1875, the first dam was built on what is now Lake Aloha. Additional dams were constructed from 1934 to 1955 in part to stabilize seasonal water flows. Although technically a dam is a nonconforming structure within federally designated wilderness areas, these dams were considered essential to downflow water management and were incorporated into the 1969 Wilderness authorization. This photograph was made in 1932. (Courtesy of Special Collections, University of Nevada, Reno.)

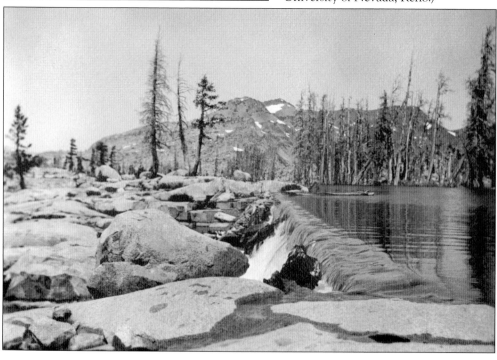

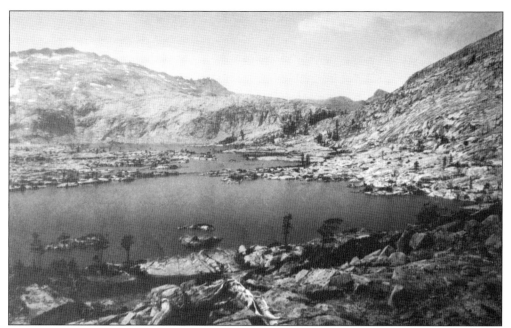

This book's multiple views of Desolation Valley, including these two, attest to the area's popularity over time. The Pacific Crest Trail skirts Lake Aloha's eastern shoreline, providing spectacular views of the Crystal Range. The lake is composed of many boulders and tiny islands, delighting hikers with a multifaceted shoreline of promontories and inlets. Lake Aloha is clearly picturesque, surrounded by the towering Pyramid Range to the west, Jacks and Dicks Peaks to the north, and Mount Tallac to the northwest. In arid years, Lake Aloha lowers substantially late in the season, revealing hundreds of small islands. (Above, courtesy of the Bancroft Library, University of California, Berkeley; below, courtesy of Special Collections, University of Nevada, Reno.)

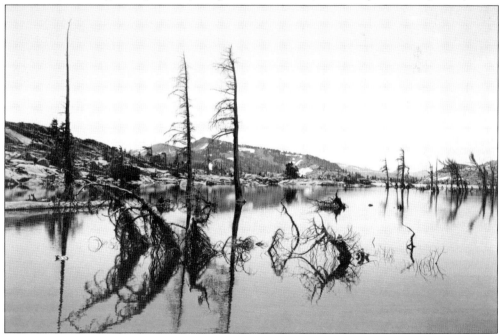

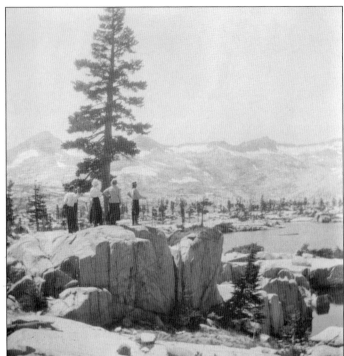

These hikers perched on top of boulders seek a better view of Desolation Valley and the Crystal Range. While resource exploitation was dominant early in Lake Tahoe's recorded history, this August 1915 photograph attests to the human desire for wildness, reflecting Henry David Thoreau's famous quote, "In wildness is the preservation of the world." (Courtesy of the Placer County Archive & Research Center, Placer County Museums.)

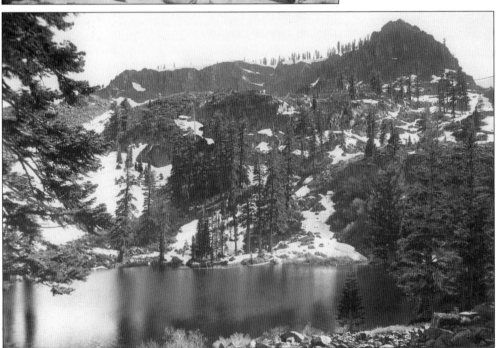

Cathedral Lake is located immediately west of Fallen Leaf Lake via the Mount Tallac trail. At 9,735 feet, Cathedral Peak towers over the lake from the south. Carl Fluegge, expert guide, opened Cathedral Park resort on Fallen Leaf Lake's west shore. Cathedral Lake is about two miles away from the trailhead, slightly over a half mile beyond Floating Island Lake. (Courtesy of the Placer County Archive & Research Center, Placer County Museums.)

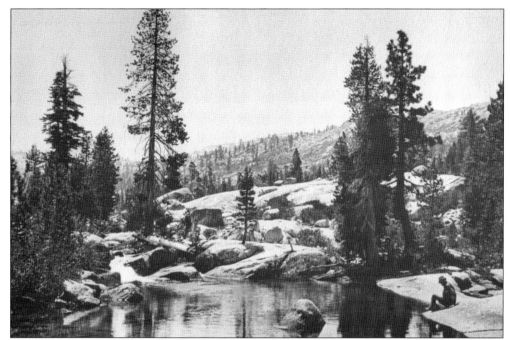

Buck Island Lake is technically just outside the boundary of the Desolation Wilderness but included here due to its proximity to Rockbound Lake to the immediate southeast. Comparing the usage of both lakes distinguishes between Sierra lakes where vehicles are permitted (Buck Island Lake) and where they are not (Rockbound Lake). Hunters from McKinney Bay probably named Buck Island Lake. (Courtesy of the Bancroft Library, University of California, Berkeley.)

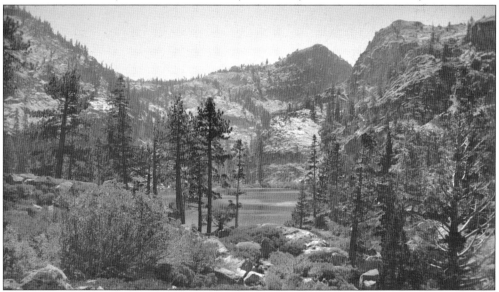

Emerald Bay was originally given the name "Eagle Bay," and Eagle Falls was occasionally known as "Emerald Bay Falls." Eagle Lake was recognized on maps as early as 1889. Eagle Falls, directly behind Vikingsholm, is one of the most photographed waterfalls throughout the Lake Tahoe Basin. *Eagle* as a place name derives from the plethora of eagle nests especially on the eastern shore of Emerald Bay. (Courtesy of the Black Rock Institute.)

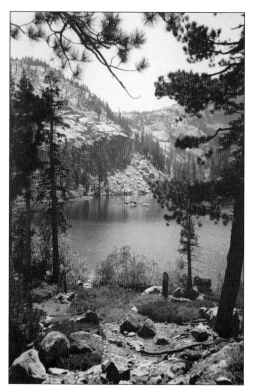

Eagle Lake is well known as an accessible Desolation Wilderness lake just a mere mile from the trailhead parking lot along Highway 89. There are two parking areas—the smallest is dedicated for Eagle Lake and the other is the parking lot just slightly to the north and east above Emerald Bay. The lot on the east side of the highway funnels visitors to a walking road heading downhill to historic Vikingsholm at the edge of Lake Tahoe. Once visitors arrive at the lake's shore, a quarter-mile trail leads to the base of Eagle Falls where, during periods of high water flow, a wave of heavy mist flows over the viewing platform. From the Eagle Falls' trailhead, the steep trail follows Eagle Creek and then opens up to a grand vista flanked by Maggies Peaks to the southeast and Phipps Peak to the northwest. Anglers in flotation devices occasionally punctuate the lake's stillness. This photograph was made around 1945. (Courtesy of the Black Rock Institute.)

Eagle Lake is family friendly, but it is often congested given the few resting areas accessible along the shoreline and due to the generous ease-of-access from the Emerald Bay Highway 89 parking area. There is a fee for parking, and during summer months, it is almost always full, so visitors will park along the narrow shoulders lining the circular roadway. The trail is well marked and leads directly to this popular lunch spot. On almost any day, visitors will notice day hikers reclining on the large granite boulders where the trail and lake intersect. They are enjoying the bright high-country sun and breathing the pure mountain air. Continuing forward, the trail gets steeper and more remote but offers majestic views of the Desolation's Sierra alpine wonderland. A few hardy visitors will hike to the three Velma lakes, Dicks Lake, and Fontanillis Lake. These lakes are relatively close together and are only five miles from the Eagle Falls trailhead. Each lake offers forested shorelines, secluded campsites, and excellent fishing. (Courtesy of the Black Rock Institute.)

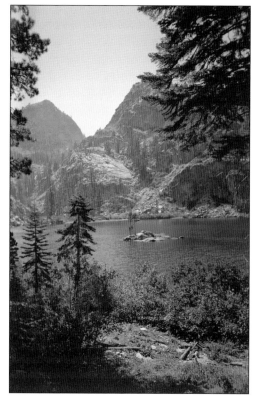

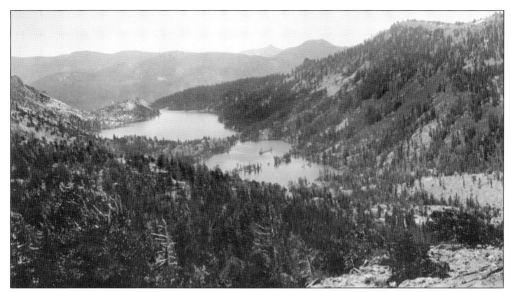

This 1930 view is from below Keiths Dome (8,646 feet), looking across both Upper and Lower Echo Lakes in the direction of Waterhouse Peak. The Desolation Wilderness boundary lies between where the photographer stood and the two lakes, near Cagwin, Ralston, and Tamarack Lakes, which are just below the view and to the right. (Courtesy of Special Collections, University of Nevada, Reno.)

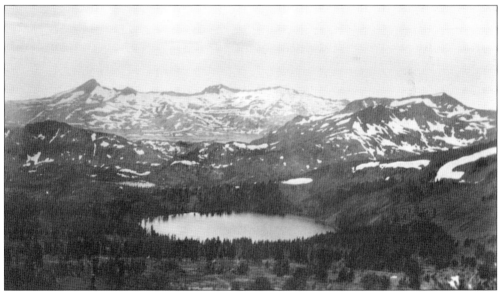

This vernacular photograph of Lake Gilmore, Pyramid Peak (left), and the Crystal Range was made from Mount Tallac in 1935. During 1873, Nathan Gilmore brought cattle and Angora sheep to graze the alpine meadows. In 1886, he homesteaded 166 acres on the southeastern side of Fallen Leaf Lake. Gilmore Lake reflects his namesake. (Courtesy of Special Collections, University of Nevada, Reno.)

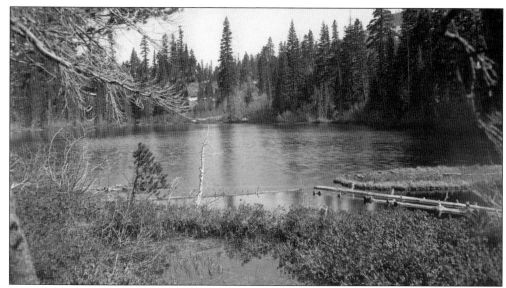

Floating Island Lake was named for the grass-covered natural island, approximately 20 feet in diameter and capable of holding (back in the day) a fishing party of four to six people. Boasting its own medium-sized conifer, the island was a distinctive feature of this five-acre lake. Today, the floating island is either adjoined to the shore or no longer present. (Courtesy of the Lake Tahoe Historical Society.)

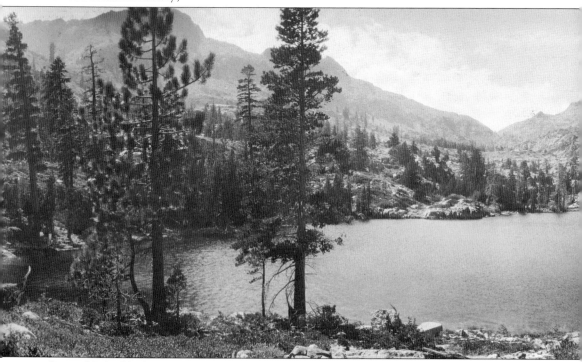

George H. Goddard was an early surveyor of the western territories and, in 1855, surveyed a part of the boundary between California and the Utah Territory (now Nevada). As his team was traversing Hope Valley into alpine country, they crossed what they described as a "pond nearly filled with rank grass." The name stuck. Goddard's 1855 map was the first to accurately locate Lake Tahoe (at the

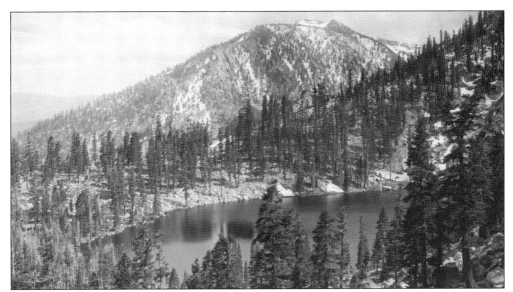

Granite Lake is nestled into a hollow below the eastern edge of Maggies Peaks. The lake is easily reached from the Bayview trailhead at Inspiration Point along Highway 89. Mount Tallac is the prominent peak in the distance. This lake is glacial in origin and is, reputedly, excellent for the angler. The hike offers panoramic views of Lake Tahoe. (Courtesy of the Lake Tahoe Historical Society.)

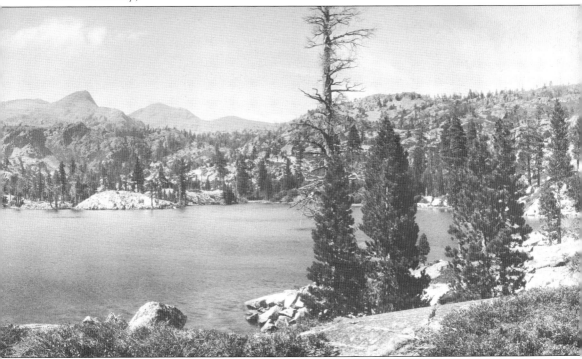

time, Lake Bigler), and the map shows towns, settlements, trails, wagon roads, county boundaries, and Grass Lake, among others. Relief is indicated by hachures, and in some cases, spot elevations were recorded. Grass Lake is easily accessible from the Glen Alpine Trailhead. This c. 1915 photograph was made by Louis H. Bannister. (Courtesy of the Lake Tahoe Historical Society.)

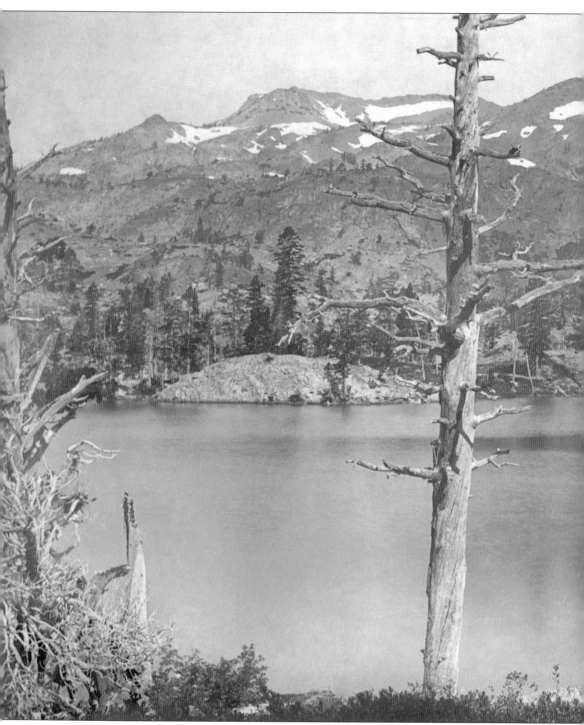

This c. 1886 panorama "Grass Lake" is from professional landscape photographer Raper J. Waters's *Lake Tahoe Series*, where high-quality photographs were printed on paper and mounted on cardstock. Waters was born in Virginia City, Nevada, in 1855 and worked out of Gold Hill, Nevada, before he settled in San Francisco. His views of the 1906 earthquake are well known.

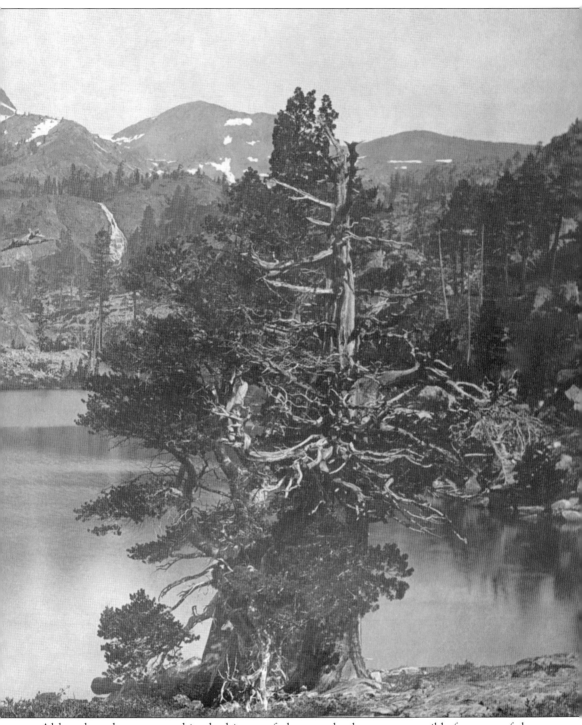

Although underrepresented in the history of photography, he was responsible for many of the seminal images of Lake Tahoe. He also served as the purser aboard the steamer *Tahoe*, which explains his easy access to many of the trailheads. (Courtesy of Special Collections, University of Nevada, Reno.)

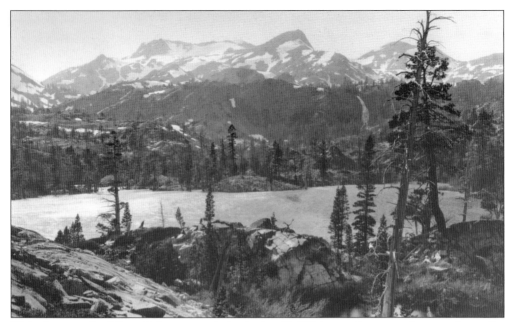

This photograph of Grass Lake was made by Arthur C. Pillsbury, who ran a photography studio and bicycle shop in Palo Alto in 1894. From 1896 to 1928, he operated the Studio of the Three Arrows in Yosemite Valley. In San Francisco, he established the Pillsbury Picture Company (1906). Pillsbury made lantern slides and Orotones (printed on glass, backed in gold) from some of his images. (Courtesy of North Lake Tahoe Historical Society.)

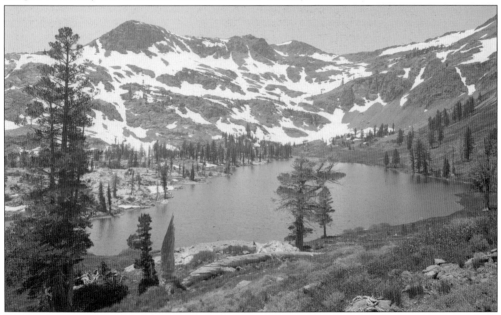

Half Moon Lake was named based upon its shape. The lake is the northwestern point of the triangle of lakes, including Gilmore and Susie. The lake is nestled within the bowl created by Dicks and Jacks Peaks; Mount Tallac is just to the northeast. Half Moon Lake is a quiet, protected lake with excellent fishing. (Courtesy of the Seaver Center for Western History Research, Los Angeles County Museum of Natural History.)

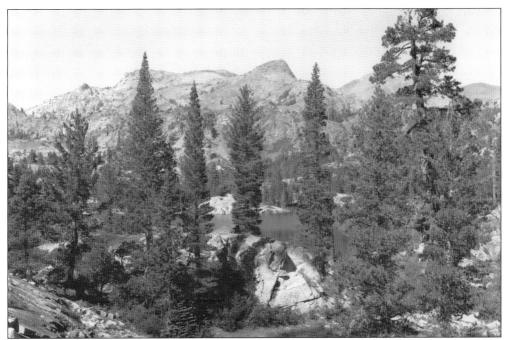

Grass Lake is part of the watershed for Fallen Leaf Lake. In 1991, the author published *Stopping Time: A Rephotographic Survey of Lake Tahoe* that includes this photograph and the one at the top of page 108. Pyramid Peak, the central identifying peak in the Desolation Wilderness, is located in the center. Rephotography provides an opportunity to study and evaluate landscape change especially in alpine environments. The image was made by the author in 1989. (Courtesy of the Peter Goin Collection.)

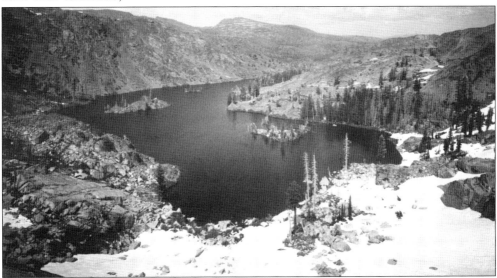

This view of Heather Lake was made from the Tahoe Rim Trail/Pacific Crest Trail. The Tahoe Rim Trail is a 165-mile-long loop circumnavigating the Lake Tahoe Basin. Approximately 96 miles of the trail along eastern and southern Lake Tahoe Basin are designated as a National Recreation Trail. This c. 1900 photograph was probably made by John Putnam or his son Arion. (Courtesy of the North Lake Tahoe Historical Society.)

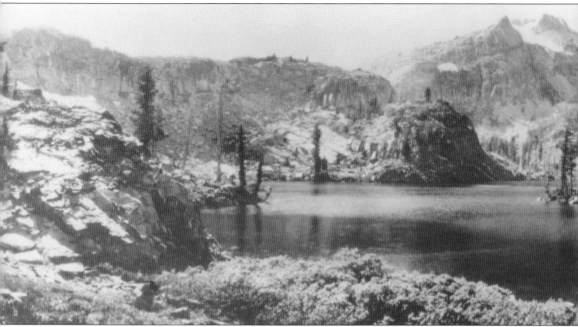

Heather Lake's name derives from the natural gardens of white and purple heather that borders the southern end of the lake. There is a small island in the lake's center. Heather Lake's scenery is wild with steep granite slopes, which are often covered with snow. Heather Lake is a classic alpine lake surrounded by rocky peaks with forest abiding the shoreline. Red fir and lodgepole

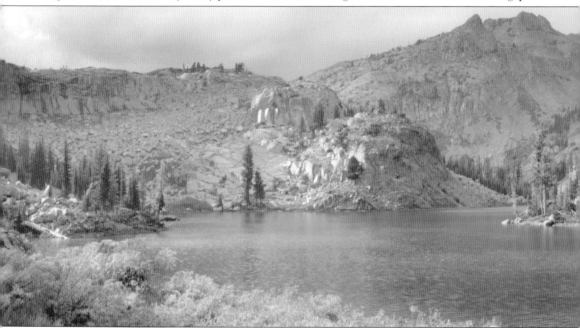

Heather Lake is about five miles from the Glen Alpine trailhead, past Lily Lake. The Glen Alpine Trail is one of the most popular gateways to multiple lakes and trails in the Desolation Wilderness. Lake Aloha, the Desolation Wilderness's largest body of water, lies just to the south; Jacks Peak to the west; and Cracked Crag to the southwest, just beyond Lake LeConte. This view of Heather

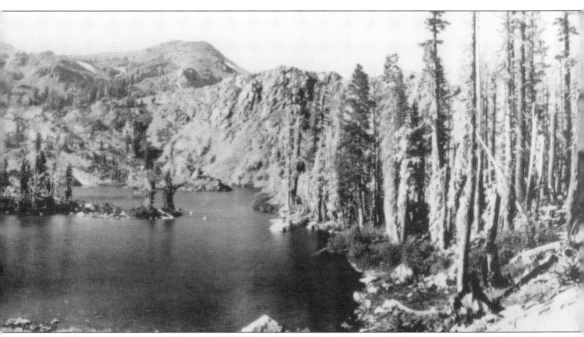

pine forests are common between 7,400- and 9,000-foot elevation. The most extensive forested areas are found on moist soils bordering lakes as the ground surface throughout the Desolation Wilderness is bedrock granite. (Courtesy of the Lake Tahoe Historical Society.)

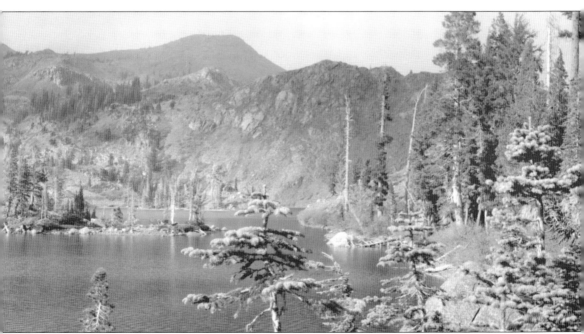

Lake closely approximates the previous view at the top of this page. One observation reveals the change in vegetation, indicating the presence of a wide diversity of annual and perennial plant life. Aspen and willow are common throughout these alpine wetlands. The image was made around 1990 by Stephen Davis. (Courtesy of the Peter Goin Collection.)

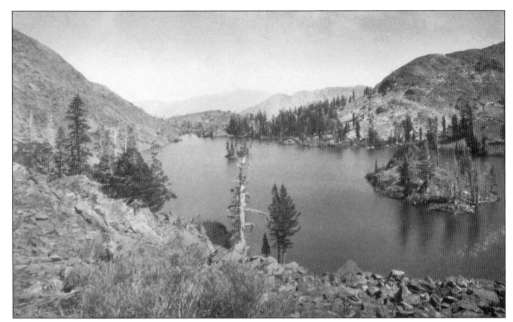

The trail follows Susie Lake's south shore and then Heather Lake's north shore, where this view was made. The trail continues to the east side of Lake Aloha. Most photographs were and are made from the trailside, providing visual evidence of the same or similar view over time. (Courtesy of the Bancroft Library, University of California, Berkeley.)

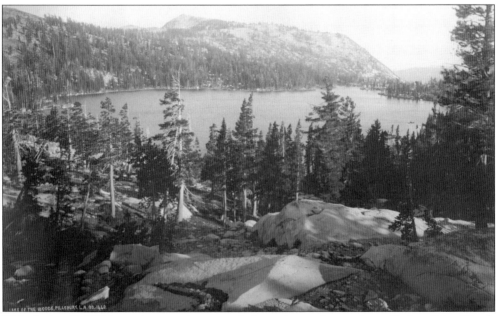

This Arthur C. Pillsbury photograph was made from the southern edges of Lake of the Woods looking northeast and includes Ralston Peak (9,239 feet). This popular climbing mountain offers spectacular views of Highway 50 and Lake Tahoe. The original 1890s photograph predates the Tahoe Rim Trail and the Pacific Crest Trail, now located just a scant half mile to the northeast. (Courtesy of the North Lake Tahoe Historical Society.)

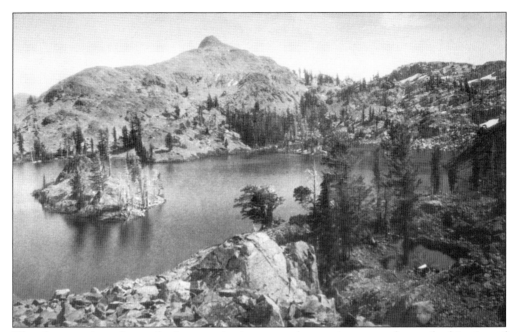

The photographer who made the opposite image on the previous page also made this view of Heather Lake. Together, if these two images were merged, the result would be a panorama, although this view was made farther along the trail. Cracked Crag is the prominent peak in the distance. Keiths Dome, Echo Peak, and Hawkins Peak are to the northeast. (Courtesy of the Bancroft Library, University of California, Berkeley.)

"Tony & Faye, the Unsinkables, Lake of the Woods" derives from the Camp Chonokis album, 1942. Camp Chonokis, a well-known camp for girls, conducted numerous hikes and tours throughout the alpine wilderness. The Lake of the Woods landscape is replete with lodgepole pines and hemlocks, medium-sized evergreen trees. (Courtesy of the Lake Tahoe Historical Society.)

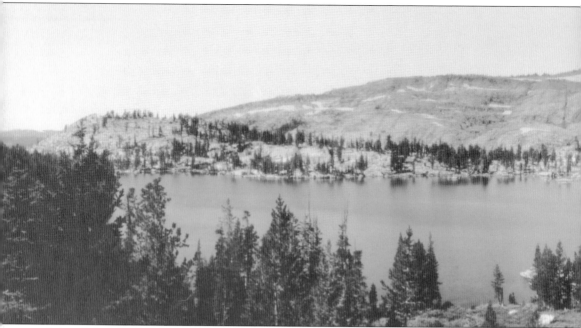

Lake of the Woods (8,048 feet) is a glacial lake within the Desolation Wilderness, El Dorado National Forest. This lake is southeast of Lake Aloha. Most hikers approach Lake of the Woods via the Echo Lake trailhead, in part due to the water taxi run by the Echo Lakes Chalet. Echo Chalet is a high Sierra summer-only resort, established in 1939. Pyramid Peak is noticeable close

The namesake lilies of Lily Lake are visible here. According to Barbara Lekisch's *Tahoe Place Names*, Nathan Gilmore, of Glen Alpine, discovered the lake in 1863. Late-19th-century accounts noted that anglers paddled the lake with oars covered in golden lily pads. Lily Lake, between Angora and Cathedral Peaks, was one of the featured lakes in Glen Alpine's promotional literature.

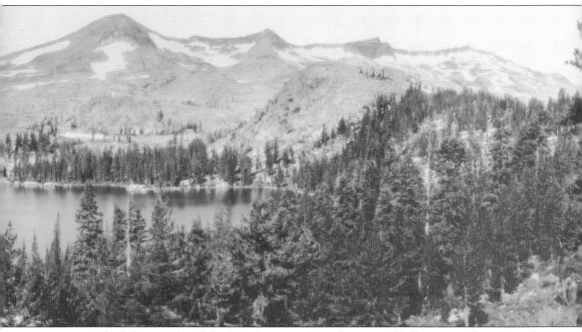

to center. The hike to Lake of the Woods passes through a mix of Jeffrey pine, white fir, and sierra juniper, and then opens into large granite landscapes punctuated by Haypress Meadow's large grassy areas. (Courtesy of the Lake Tahoe Historical Society.)

Glen Alpine Springs delivers water into Glen Alpine Creek, feeding Lily Lake and Fallen Leaf Lake. The creek flows across steep, jagged rocks forming waterfalls, cascades, and deep pools. Lily Lake is outside the wilderness boundary but included here because it is a gateway lake and often misconstrued as part of the wilderness. (Courtesy of the Lake Tahoe Historical Society.)

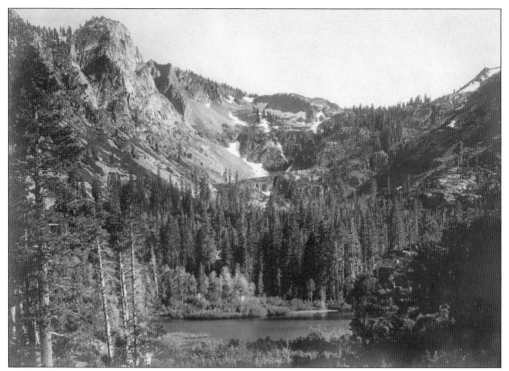

The flanks of Angora Peak (8,588 feet) are barely visible at far left. The prominent outcropping in this view is unnamed yet adds a strong visual accent to the grand view. Lily Lake is small by comparison to most Desolation Wilderness lakes. The shoreline has notable grasses and reeds, surrounded by a dense alpine forest. The gateway to the Desolation Wilderness enters through the pass. (Courtesy of the California Historical Society.)

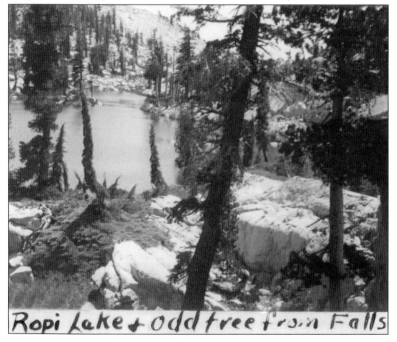

"Ropi Lake & Odd Tree from Falls" is a 1933 view by Camp Chonokis campers Anne and Irmy (no last names identified). Horsetail Falls is located to the southeast; it is possible that the hikers mistook Roni Lake for either Avalanche or Pitt Lake, as both are more in the line of sight from the falls. (Courtesy of Special Collections, University of Nevada, Reno.)

116

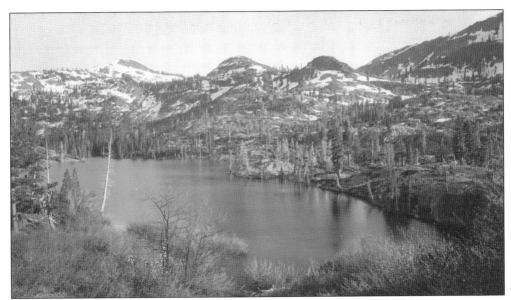

Lake Lucille, shadowed by Keiths Dome and surrounded by meadows and thick brush, is a pleasant diversion from the Pacific Crest Trail just a half mile to the south. Lake Margery is a companion lake between the trail and Lake Lucille. During the summer of 2017, the US Forest Service advised caution in this area, as the spring runoff created unstable snow pathways. (Courtesy of the Lake Tahoe Historical Society.)

Rockbound Lake was listed on the 1889 Pyramid Peak quadrangle map and is located in the northwest corner of the Desolation Wilderness, east of Loon Lake. This lake is more easily approached from the western access routes to the Desolation Wilderness, mostly via the McKinney-Rubicon Off Highway Vehicles (OHV) Trail and the pathways to Buck Island Lake, outside the wilderness boundary. (Courtesy of the Bancroft Library, University of California, Berkeley.)

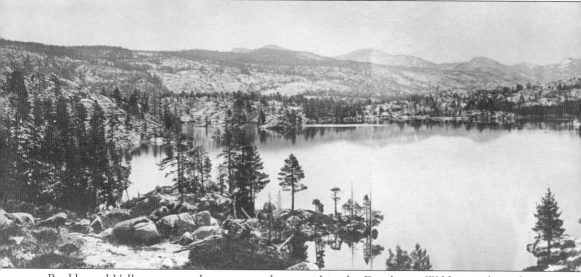

Rockbound Valley runs northwest to southeast within the Desolation Wilderness boundary. Rockbound Lake is the northwest terminus of Rockbound Valley. The name *Rockbound* identifies the lake, pass, and the valley. Rubicon Springs and Rubicon River are to the immediate north; the spring is outside the boundary of the Desolation Wilderness. Rockbound Lake is in Zone No. 1

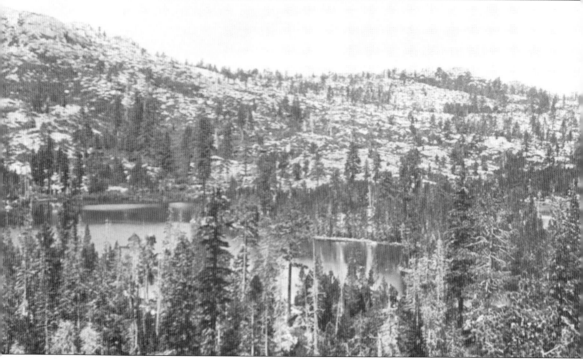

This is Rockbound Lake. This glaciated landscape with vast expanses of exposed granite rock, scattered trees, and shrubs is a hiker's paradise. The Wright's Lake Trailheads—Rockbound, Twin Lakes, and Lyons—offer easier access to the Crystal Range's peaks. These are Mount Price (9,975 feet), Mount Agassiz (9,967 feet), and Pyramid Peak (9,983 feet). Devils Peak is the predominant feature of the right side of this view of Rockbound Lake's horizon. Buck Island Lake

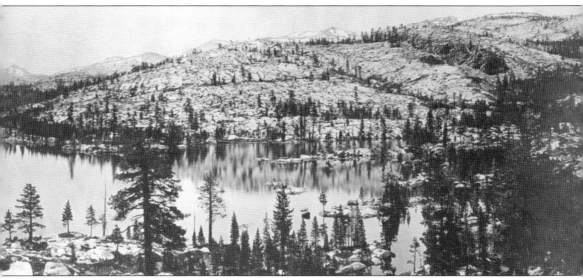

with a reservation quota of only 13. For day hiking, visitors only need to fill out a free permit at the trailhead. Overnight campers in the Desolation Wilderness must register in person and pay required fees established according to the zone quotas. Campfires are not permitted, but camp stoves are allowed. (Courtesy of the Bancroft Library, University of California, Berkeley.)

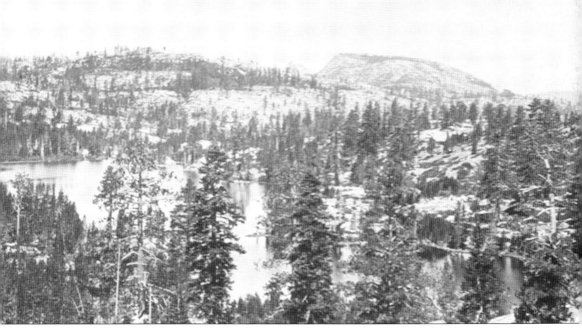

is in line with the peak but not pictured. The Desolation Wilderness boundary lies just beyond Rockbound Lake and before Buck Island Lake. In the vicinity of Rockbound Lake, reports of spectacular wildflowers and heavy mosquito activity are common. (Courtesy of the Bancroft Library, University of California, Berkeley.)

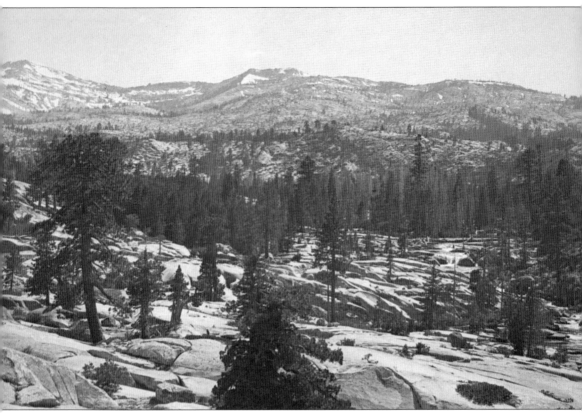

Standing on the granite ridges above the southern edge of Rockbound Lake and along what is now the Rubicon Trail, spectacular views are evident of McConnell Peak (9,099 feet), far left. Unseen in the peak's foreground is Highland Lake and to its east, Lake Zitella. Horseshoe Lake and McConnell Lake round out the lakes in the distant foreground. In the far distance,

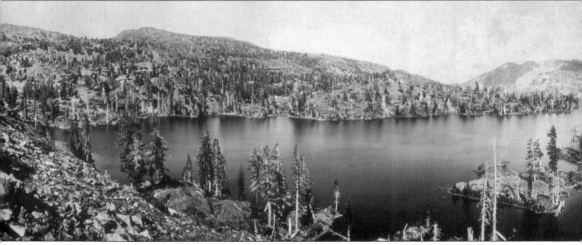

The origin of Susie Lake's name is unclear. E.B. Scott in the *Saga of Lake Tahoe* suggests that the lake was named after Susan Gilmore, Nathan and Amanda Gilmore's oldest daughter. Robert A. Wood relays that the lake's name originated from a matriarch of the Washoe who camped throughout the summer at Lake Tahoe. Robert A. Wood includes a photograph of "Susie, the

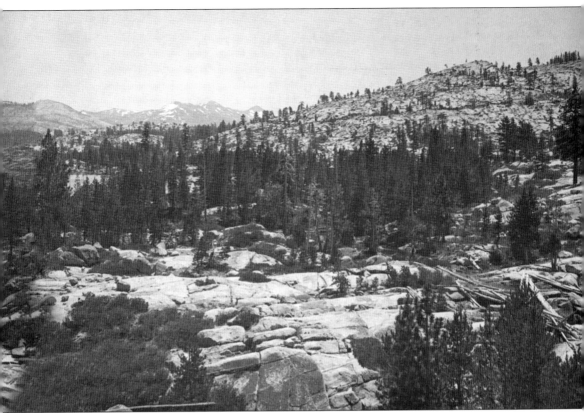

slightly right of center, is Middle Mountain (8,337 feet), and then center left are Dicks and Jacks Peaks. Pyramid Peak is barely visible where the distant range intersects the slope of the granite divide. Rockbound Valley is in this sightline. (Courtesy of the Bancroft Library, University of California, Berkeley.)

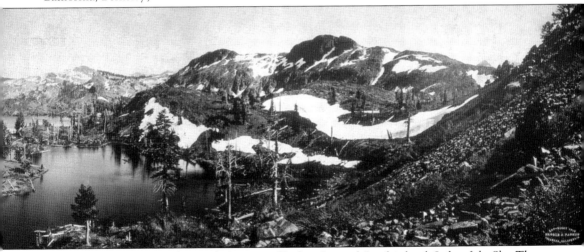

Washoe Indian Basketmaker, and Narrator of Indian Legends" in his book *Lake of the Sky*. The Pacific Crest Trail and the Tahoe Rim Trail pass directly along the southeastern edge of Susie Lake. This 1910 photograph was made by Harold A. Parker. (Courtesy of California History Room, California State Library, Sacramento.)

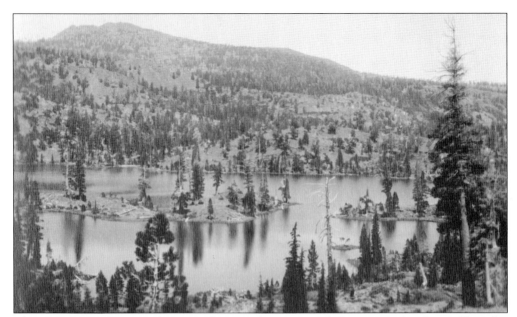

This 1930 view of Susie Lake is another in a long series of photographs by Camp Chonokis hikers. Although originally intended to record the scenic beauty and to memorialize through photography an alpine experience, these photographs have become some of the most prescient images of the Desolation Wilderness from 1927 through the early 1940s. (Courtesy of Special Collections, University of Nevada, Reno.)

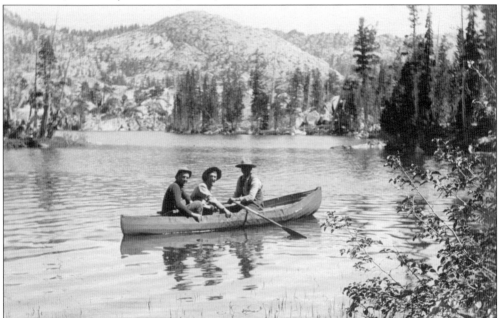

There are three Lake Velmas in the Desolation Wilderness. More mundane than lyrical, they are Upper, Middle, and Lower Velma. The name originates from Harry Oswald Comstock, Tallac House manager, who requested that a lake be named after his daughter. Harry Comstock only had one daughter named Velma. The three lakes are the first hikers encounter after passing Eagle Lake, above Emerald Bay. (Courtesy of the Lake Tahoe Historical Society.)

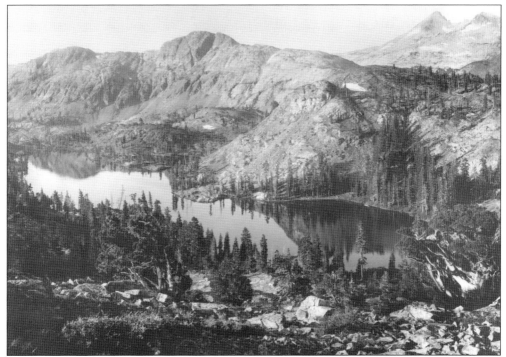

Cracked Crag rises above Susie Lake, looking south. Heather and Aloha Lakes are beyond the ridgeline, and Pyramid Peak is barely noticeable in the far distance, right. This view encompasses almost all of Susie Lake, reflecting the conceptual focus during the 19th century among professional photographers. Susie Lake appeared in the 1889 Pyramid Peak 30-minute map (one inch equals approximately two miles and covers 30 minutes of latitude and longitude) . (Courtesy of the North Lake Tahoe Historical Society.)

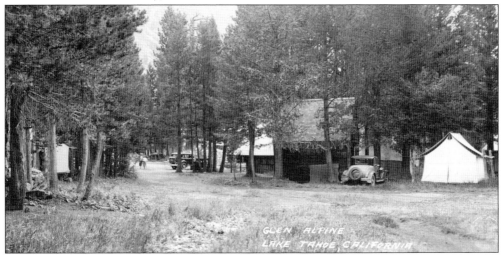

Originally a natural wildlife sanctuary, Glen Alpine was operated as a grazing site, then a resort, and today as a historic site. Although Glen Alpine is outside the boundary of the Desolation Wilderness, it is a gateway to the area and part of the Desolation Wilderness's history. Nathan Gilmore discovered and subsequently exploited the springs that are near Fallen Leaf Lake. (Courtesy of Special Collections, University of Nevada, Reno.)

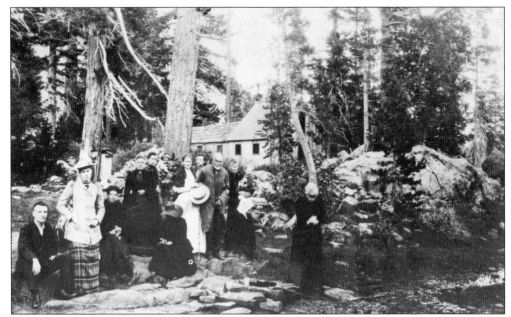

Amanda Gray Gilmore, Nathan's wife, chose the name "Glen Alpine" from Sir Walter Scott's 1810 narrative poem "The Lady of the Lake." Considered standard reading in elementary schools until the early 20th century, this romantic poem has no relationship to the Lake Tahoe region, until this naming. The Gilmores developed what was considered to be a first-class resort at the site. (Courtesy of the Lake Tahoe Historical Society.)

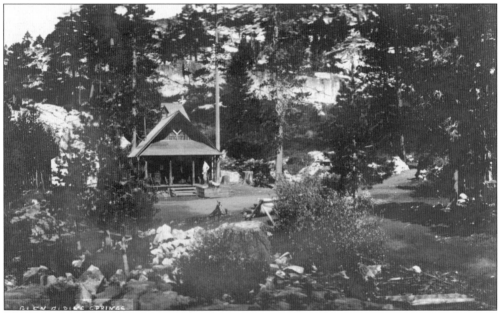

This June 30, 1911, postcard features the Glen Alpine office within its alpine surroundings. Many well-known luminaries in the 19th and early 20th centuries visited Glen Alpine, including John Muir, naturalist, environmental philosopher, and early advocate for the preservation of wilderness, especially western forests. Muir was largely responsible for the designation of Yosemite as a national park. (Courtesy of Special Collections, University of Nevada, Reno.)

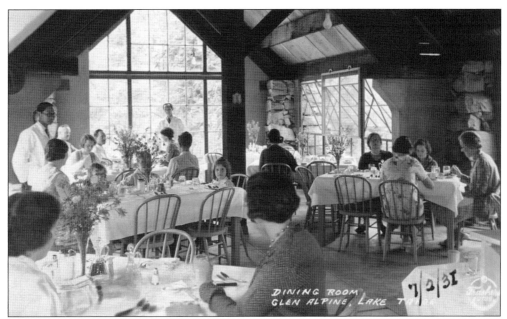

"Dining Room, Glen Alpine, Lake Tahoe" offers a glimpse into formal resort dining during the early 1930s. Bernard Maybeck, noted Berkeley, California, architect, designed the social hall, a one-room building made of steel, redwood, stone, and glass. Today, Glen Alpine lies within the jurisdiction of the Lake Tahoe Basin Management Unit of the US Forest Service. This photograph was made by Burton Frasher and dated July 2, 1931. (Courtesy of the Jill Beede Collection.)

From the late 1890s through the 1930s, guests came to relax in the exclusive mountain resort, enjoying the healing powers of the spring's waters. Glen Alpine boasted 25 buildings, including a 16-room hotel, barn, dining room, icehouse, kitchen, office (pictured here), and post office. Tent cabins were available to those not staying in the hotel. (Courtesy of the Lake Tahoe Historical Society.)

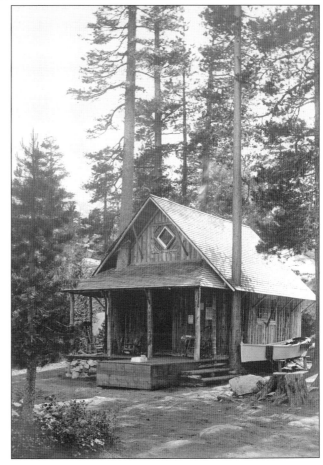

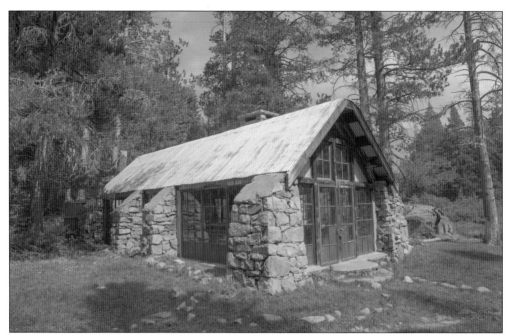

In 1920, Edward Gray Galt purchased Glen Alpine Springs for $10,000 and hired noted architect Bernard Maybeck, who designed 20 fireproof buildings, of which six were constructed, including this assembly hall. The design reflects Maybeck's deliberate effort to blend the granite stone, glass, and metal with the alpine environment. This image was made by the author in 2017. (Courtesy of the Peter Goin Collection.)

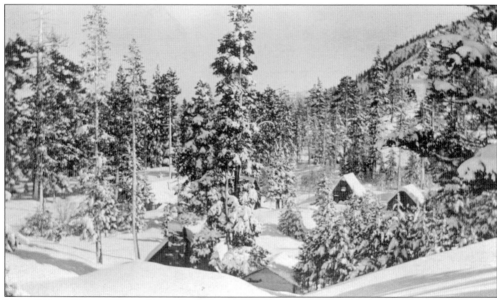

This "Glen Alpine Winter" overlooks a serenely beautiful resort embraced within a winter wonderland. Even the spring water was touted as having therapeutic benefits and was, for a time, bottled and sold as an elixir of health. The Glen Alpine Post Office operated from 1904 until 1918, when it was relocated to Tallac and later to Camp Richardson. (Courtesy of the Jill Beede Collection.)

Nathan Gilmore discovered the Soda Springs in 1863 and built the resort two decades later. He introduced Angora goats to the Fallen Leaf Lake area and from which Angora Peak, Lake, and Ridge are named. For more than 40 years, visitors to Glen Alpine enjoyed the crisp alpine air and the curative "Clan Alpine Mineral Water" from this source still evident today. The author made this photograph in 2017. (Courtesy of the Peter Goin Collection.)

The road to Glen Alpine measures the transformation of a natural wilderness into a commercial enterprise, first as a ranching operation but thereafter into an evolving tourism economy replete with its own fish hatchery. Nathan Gilmore died in 1898, and on April 13, 1899, President McKinley signed a proclamation setting aside 136,000 nearby acres as the Lake Tahoe Forest Reserve, in Gilmore's honor. (Courtesy of the Lake Tahoe Historical Society.)

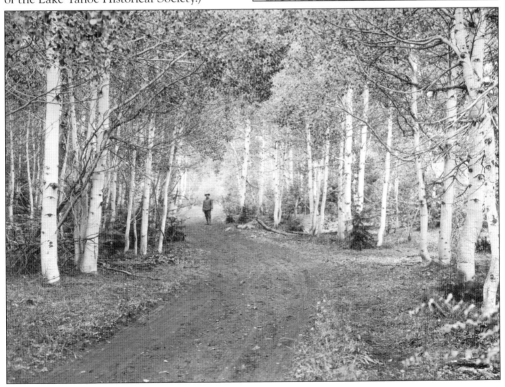

Discover Thousands of Local History Books Featuring Millions of Vintage Images

Arcadia Publishing, the leading local history publisher in the United States, is committed to making history accessible and meaningful through publishing books that celebrate and preserve the heritage of America's people and places.

Find more books like this at
www.arcadiapublishing.com

Search for your hometown history, your old stomping grounds, and even your favorite sports team.